W9-ABH-782

DISCARD

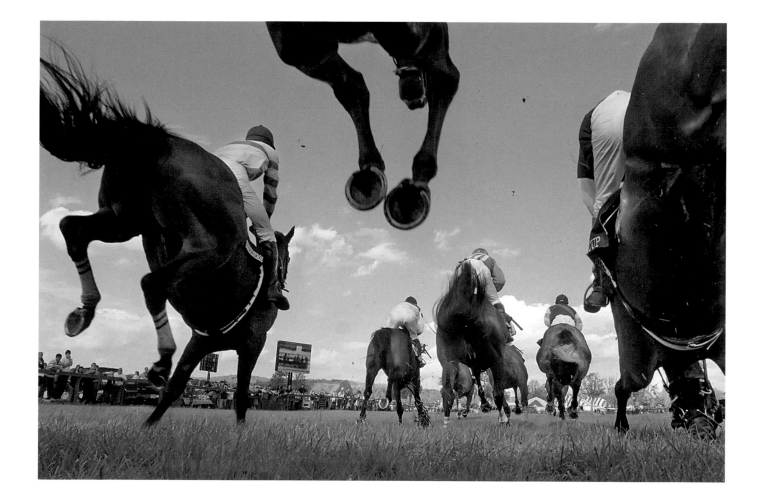

DISCARD

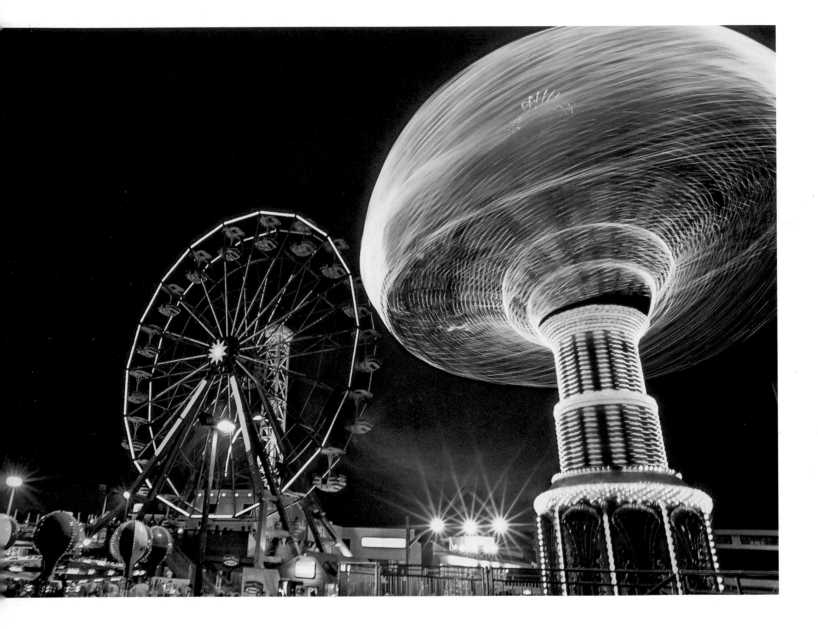

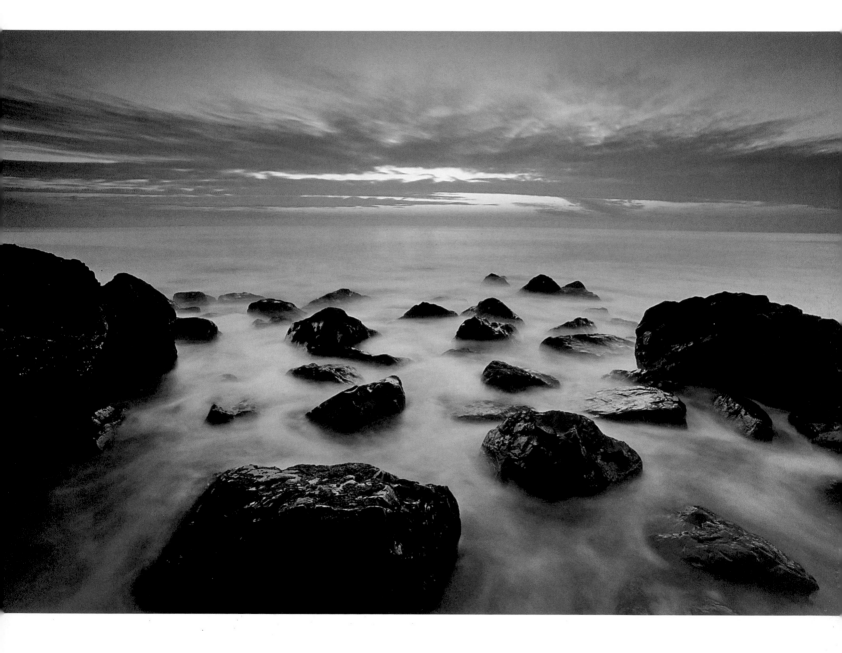

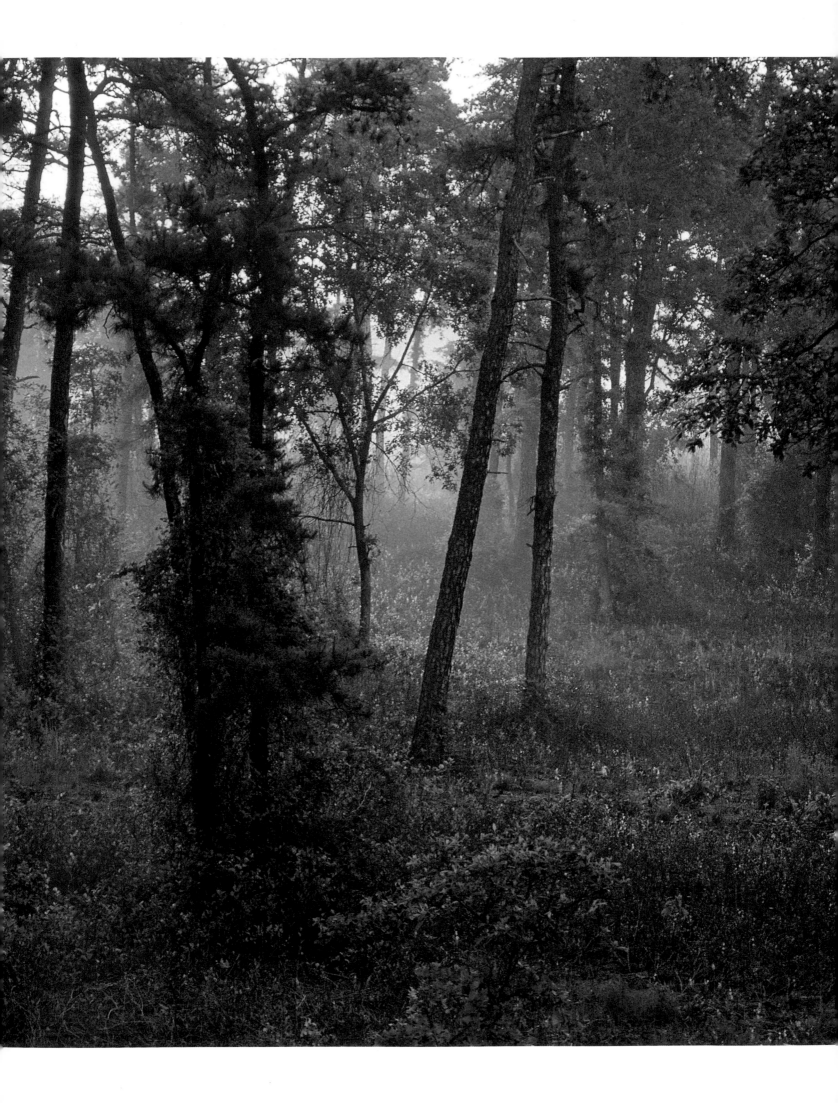

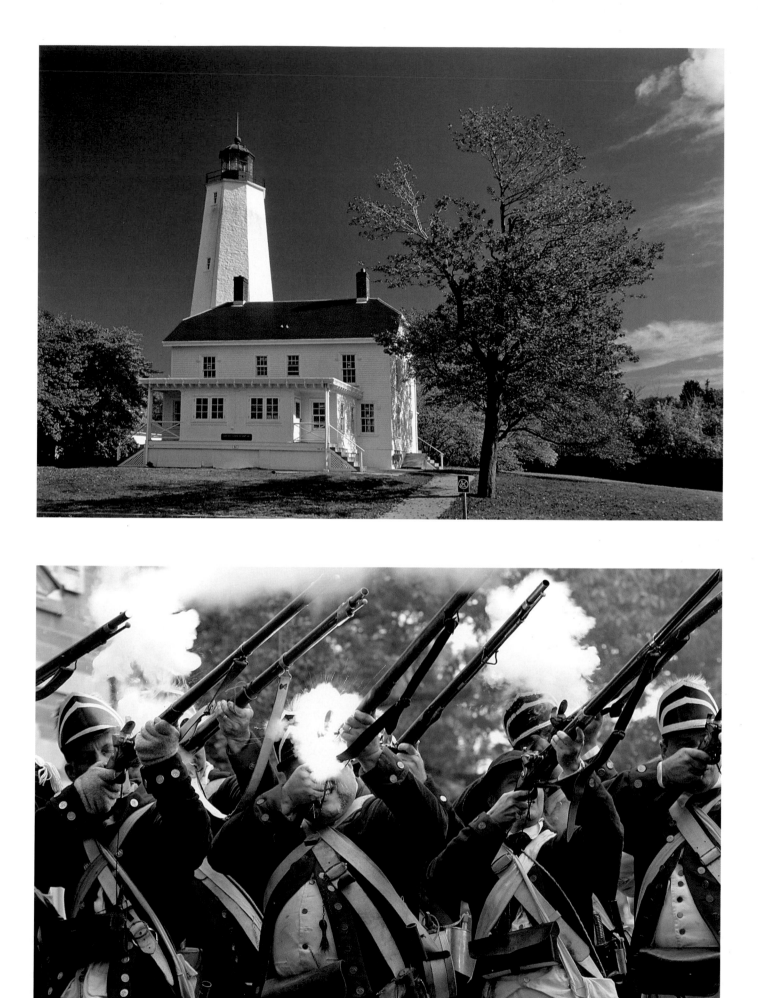

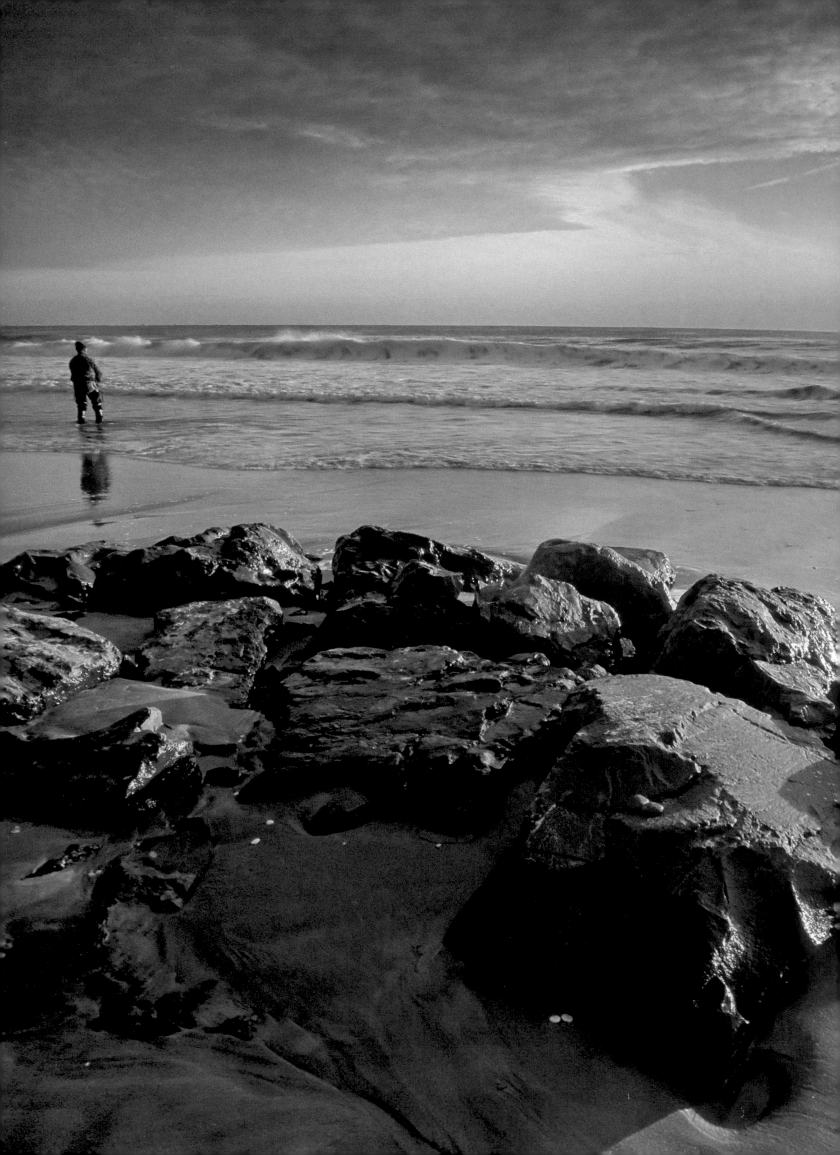

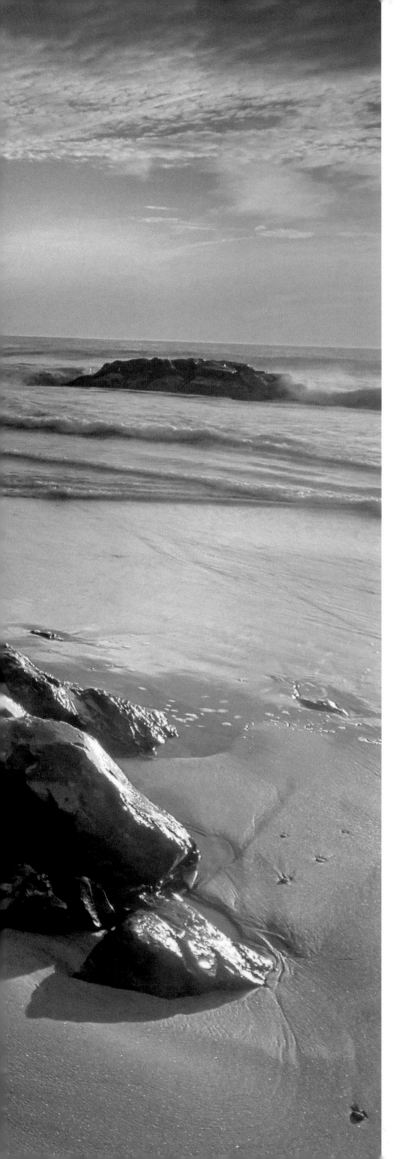

Our
New Jersey

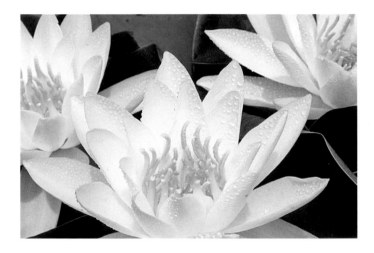

Steve Greer

Voyageur Press

First published in 2008 by Voyageur Press, an imprint of MBI Publishing Company, 400 First Avenue North, Suite 300, Minneapolis, MN 55401 USA

The information in this book is true and complete to the best of our knowledge. All recommendations are made without any guarantee on the part of the author or Publisher, who also disclaim any liability incurred in connection with the use of this data or specific details.

We recognize, further, that some words, model names, and designations mentioned herein are the property of the trademark holder. We use them for identification purposes only. This is not an official publication.

Voyageur Press titles are also available at discounts in bulk quantity for industrial or sales-promotional use. For details write to Special Sales Manager at MBI Publishing Company, 400 First Avenue North, Suite 300, Minneapolis, MN 55401 USA.

To find out more about our books, join us online at www.voyageurpress.com.

ISBN-13: 978-0-7603-3240-5

Editor: Margret Aldrich
Designer: Danielle Smith

Printed in Hong Kong

Library of Congress Cataloging-in-Publication Data

Greer, Steve.
 Our New Jersey / Steve Greer.
 p. cm.
 ISBN 978-0-7603-3240-5 (plc w/ jkt)
 1. New Jersey—Pictorial works. 2. New Jersey—Description and travel. I. Title.
 F135.G74 2008
 917.4904'44—dc22

2008017569

ON THE FRONT COVER
Funtown Amusement Pier, Seaside Heights

ON THE BACK COVER, *clockwise from left:* Mainstay Inn, Cape May; Atlantic City boardwalk; fall color on the Batsto River; Roadside Diner, Wall Township.

PAGE 1
Held at the spectacular Moorland Farms in Far Hills, the world's finest steeplechasers compete for purses of over $600,000. This annual tradition draws more than fifty thousand horse-loving revelers who return year after year.

PAGE 2
A giant 140-foot Ferris wheel and the swings are the centerpieces at Gillian's Wonderland amusement park in Ocean City. Prohibiting the sale of alcoholic beverages within its city limits, this seaside resort is known for being family-friendly.

PAGE 3
At Long Beach Island, the predawn light paints a colorful sky, presenting a lavender hue to the eternal ocean surf.

PAGE 4
Early morning sunlight streams through the fog-laden pitch-pine forest at the Peaslee Wildlife Management Area.

PAGE 5, TOP
Built in 1764, Sandy Hook Lighthouse is the oldest continuously operating lighthouse in the country. It stands in response to the pleas of New York merchants and sea captains after several disastrous shipwrecks off the coast here in 1761.

PAGE 5, BOTTOM
Waiting until British soldiers are within fifteen paces, Continental Army reenactors fire their muskets, volleying lead pellets into the air. During battle, a skilled soldier was able to fire three rounds per minute.

ON THE TITLE PAGE
A gutsy autumn sunrise opens the clouds to display the secrets of solitude to a lone surf fisherman on the central Jersey coast.

ON THE TITLE PAGE, INSET
The American white water lily was commonly used by Native Americans for medicinal purposes. Used as an antibiotic and for everything from clearing sinuses to aiding in digestion, the homeopathic practices are still utilized by doctors today.

Acknowledgements

To borrow an expression from a dear friend, it seems the things in life that hold the most lasting value are the ones that are not achieved alone. And so it is with the book you hold before you. This photographic celebration of New Jersey would not have been possible without the immense support of so many who gave willingly of their time and expertise. My experiences with the gentle and heartwarming folk of the Garden State were far richer than any image created. I am very grateful for those who allowed me an opportunity to visit their land and their lives.

In particular I wish to thank the special people at the Maple Shade Camera Club, who without their encouragement and friendship, I would not have thought myself worthy to pursue this craft in the first place.

To Joe Costanza, who willingly shared his passion for the natural world and photo expertise. Without his offer of a deep discount to his arsenal of quality glass, I would not have had an opportunity to see the world through my first real telephoto lens.

Special appreciation goes to John Bryans, a master wordsmith and professional editor, whose editorial wisdom and encouragement for the precision of language is able to transform the most mundane text into prose. Our lunchtime conversations about more than the usual trivial distractions of the day are always uplifting.

To Paul Totten, a true naturalist in every sense of the word. It is his expertise of New Jersey's threatened population of bald eagles that allowed me to experience the intimate moments of this wonderful species.

To Laurie Rivello, who awoke in me a particular language; one that I thought I had no knowledge of. I carry her expressions of love wherever I may be.

As always, my thanks and undying love go to my wife, Cindy. Her enthusiasm for adventure and belief in us inspired me to take the leash off my mind. Her remarkable courage through times of adversity alone gave me the confidence to continue to create photographs. I marvel at the thought of how small my life would be without her influence.

To my adoring children, Olivia and Cooper, whose endless energy and vitality are a wonderful source of rediscovery and exploration of life's most meaningful measures. Each day is new, basking in their glow.

And most important, this project would not have come to bear fruit without the altruistic love and support from my mentor and dear friend, Patrick Endres. His continuous and radiant guidance always to reach higher, both within myself and my art, has inspired me to strive for more in life than just documenting a moment in time, with or without a camera. I am forever in his debt for enriching my life beyond measure.

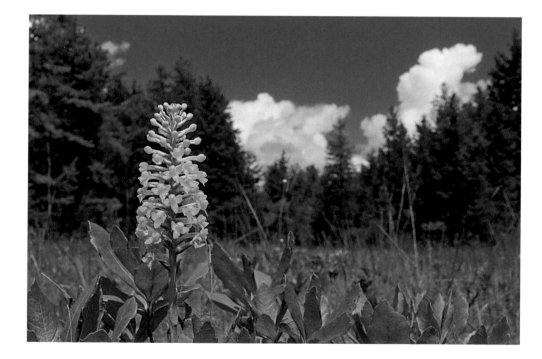

A rare southern yellow orchid blooms in a remote savannah in the heart of the Pine Barrens.

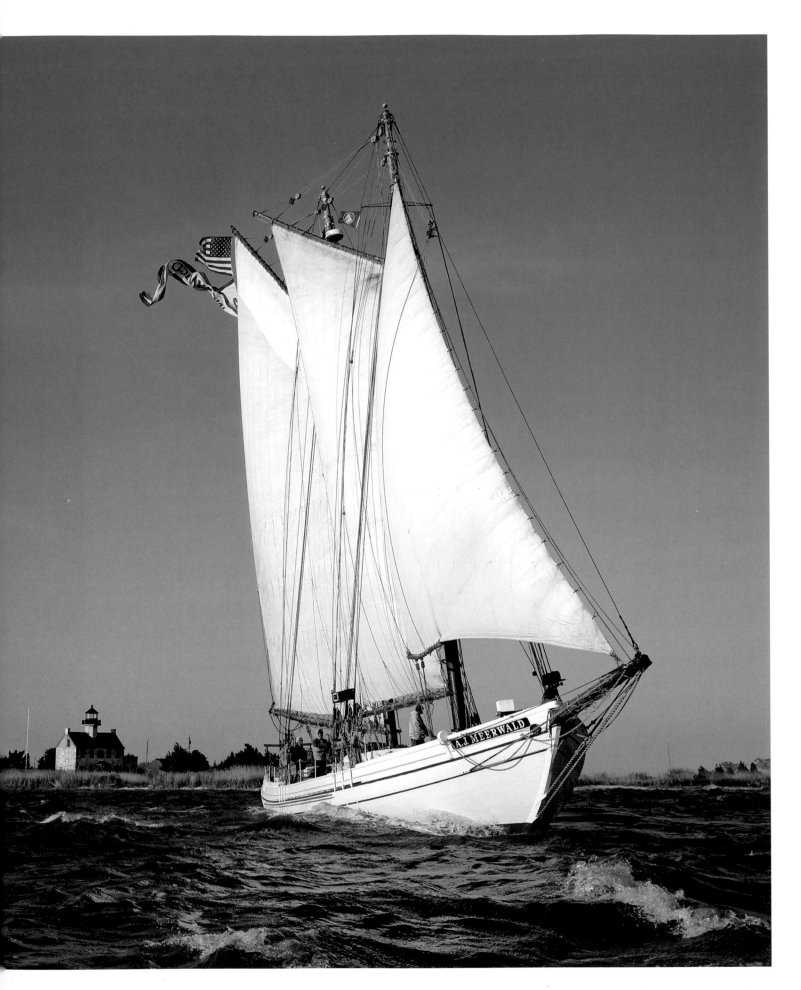

The historic tall ship, *A. J. Meerwald*, sets sail on Delaware Bay with the East Point Lighthouse off her stern. A restored 1920s oyster schooner, the *A. J. Meerwald* is designated as New Jersey's official tall ship.

Introduction

Lying in the wet sand on the southern New Jersey shore, I searched the horizon for any hint of color in an attempt to distract myself from the obvious discomforts. Shivering and sprawled out on my stomach with a camera and telephoto lens in front of me, I waited. Waited for the warmth of the new day to shed the chill of my soaked clothing. Waited for enough light that my optical nerve could register a specific shape on the sand.

And then, like the petals of a flower opening to greet the day, a cradle of pink light bathed the beach. I began scanning the shoreline for any signs of movement. With the sound of the ocean waves behind me, I could see a tiny sandstorm skittering along the beach. Looking more like an illusion than a six-inch shorebird, the piping plover's sand-colored plumage made it virtually invisible.

The first warming rays of the sun now stretched across the sand, and I could see the plover was not alone. One under each wing, her two chicks snuggled close to fend off the night chill. Suddenly, her head swiveled around toward me. It stopped. Her eyes locked onto the shiny face of my lens. I felt the tiny hairs on the back of my neck stand up. But her wary eyes saw nothing amiss. My best attempt at impersonating a piece of driftwood did not register on a brain that had evolved thousands of years ago. Soon her attention shifted back to the precocial wrestling of her two chicks, and I knew it was safe to begin photographing.

Recording the intimate moments of the piping plover in early May was my first stop in a three-year journey documenting the Garden State's treasures. During this time, I would travel hundreds of miles, crisscrossing the state in search of all that celebrates New Jersey. My intention was to make a pictorial record of its offerings, be it a rare and wild orchid, a classic Jersey diner, cowboys clinging to bucking bulls at the Cowtown Rodeo, the lights of Atlantic City, or a windy expanse of the rocky highland mountains.

The more I saw of New Jersey, the more I realized how much there was to discover in this diverse state. And while I wanted to linger, to look a little closer, nature's rhythms and people's pursuits kept me pressing on.

In late May, I traveled to join the fly-fishing community who fine-tuned their bucktails and streamers as large brook trout called them back into the sacred waters of the Raritan River. By mid-June, I ventured to coastal ports as New Jersey's tall ship, the *A. J. Meerwald,* set sail on ocean landscapes and her crew educated people about shipbuilding history and the rich marine natural resources the state has to offer.

On the evenings that were thick with humidity, I followed the familiar nasal honks of emerald green Pine Barren tree frogs deep in the pitch-pine forests. And while this thumb-sized endangered species carried out its courtship calls, far away at the Monmouth Battlefield State Park, the sounds of musket fire accompanied reenactors as they relived the battles of General Washington's army against the British in the Revolutionary War.

In July, sun-soaked days persuaded thousands of native water lilies to reveal their secrets. The spell of this spectacle could only be broken to photograph the day-trippers and summer vacationers invading the shore. People from miles around came to walk the world-famous boardwalks, sail the calm summer ocean and back bays, attend kite-flying festivals, and partake of the lively nightlife in the coastal resort towns.

Shaking the sand off my camera, I traveled to county fairs, photographing children of all ages enjoying cotton candy and listening to the 4-H club describe where their breakfast milk comes from. In August, Native Americans hosted an authentic powwow, offering visitors an opportunity to experience history not available in any textbook. Only after the drums subsided would I venture north to the peaks of the Kittatinny Ridge.

By September, the historic horseracing traditions at Monmouth Park and Far Hills were in full gear, inviting world-class horsemen to compete for the largest purses in the country. Farther south, cranberry farmers flooded their bogs in anticipation of harvesting the ruby red crops. And with the floating berries collected and ready for market, falling autumn leaves and crisp winter winds provoked snowfalls throughout most of the state, even providing rare blankets of the white stuff along the southern coastal beaches.

The magic of these transformed landscapes was all too brief. The lengthening days loosened winter's grip, allowing snow melt to flow through mountain streams and ripen the hardy white-water kayaker's appetite for adventure. During winter's final days, my cold hands reminded me to warm myself to the brilliant sounds of New Jersey's symphony orchestra at the New Jersey Performing Arts Center in Newark.

Spring ushered in the prolific pink blooms of more than two thousand cherry trees at Branch Brook Park, located in the heart of the state's largest city. While not wanting to leave the captivating aroma of the blossoms, I was motivated to travel over one hundred miles to photograph horseshoe crabs by the thousands as they climbed out of the frigid waters of the Delaware Bay and onto the beaches to lay their eggs. Wherever coastal sky met liquid earth, the season's spectacular sunrises revealed this ancient migration.

All of this was ahead of me as I lay on the beach watching the piping-plover chicks chase insects and marine worms, and listening to the cacophony of sound ringing brilliant and clear from the communal gathering of new shore life.

I visited the plover family each morning over the next three weeks. Through my powerful lens I had the privilege to witness the struggles and triumphs of these tiny fluff balls and the daunting vigilance of both parents.

Although I didn't know it at the time, this was to be the most poignant experience of my New Jersey odyssey. This small stage of wind and sand was a metaphor for the state's great drama of landscape and wildlife and the fascinating people who are its faithful stewards.

Picking myself up off the wet sand and leaving the beach for the last time, I heard a jewel-toned peep that I had come to know so well. I turned in time to see the rapid wing beats of the newest piping plover as it flew for the first time. This tiny wisp of sand had seen the sun rise over the rolling ocean surf, had snuggled against its mother's warm breast on chilly nights, and had witnessed the phenomenon of thousands of other shorebirds wheeling through the air. For the plover, and for me, it was time to move on.

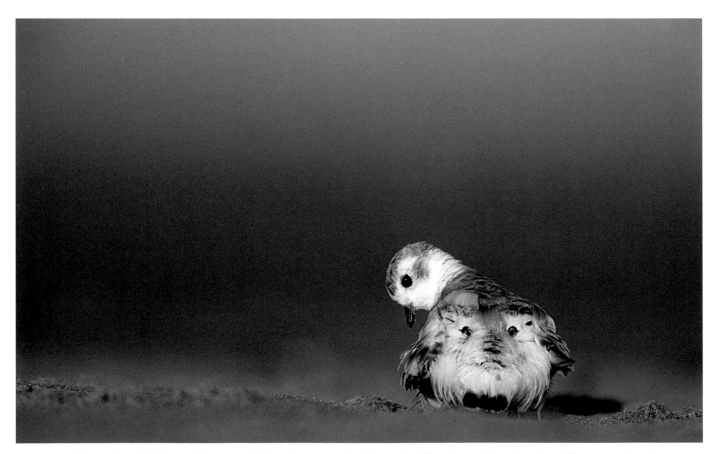

A piping plover shorebird keeps her two chicks warm on the tide-soaked beach, waiting for the rising sun to begin warming the day.

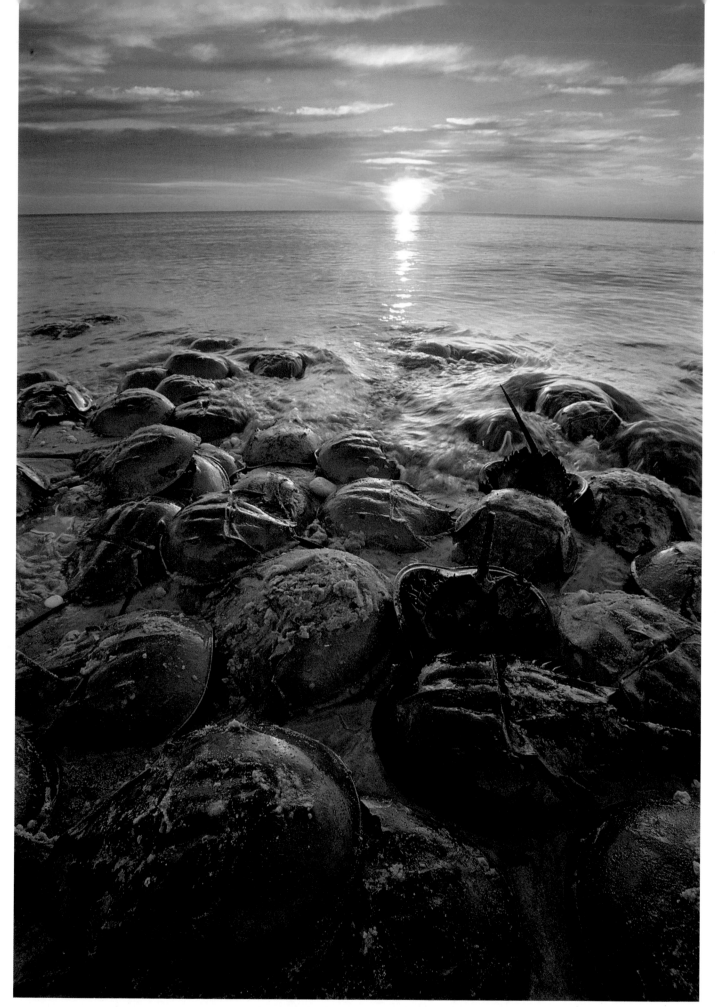

Thousands of horseshoe crabs crawl out of the frigid waters of Delaware Bay and onto New Jersey beaches to mate and lay their eggs in the sand. This ancient phenomenon predates dinosaurs and occurs only on the high tides, in near or total darkness, once a year in May.

As they have for eons, the numerous waterfalls at Van Campens Glen continue methodically to carve their way through the Delaware Water Gap, eventually reaching the Delaware River.

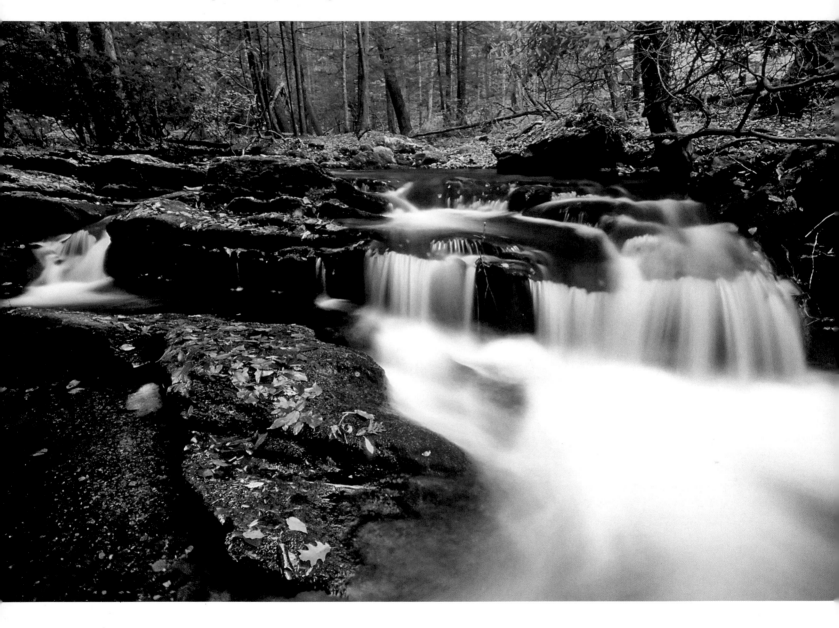

The coolness of a quiet wetland basin in the Delaware Water Gap is an idyllic spot for sphagnum moss to form an emerald green mat over the forest floor.

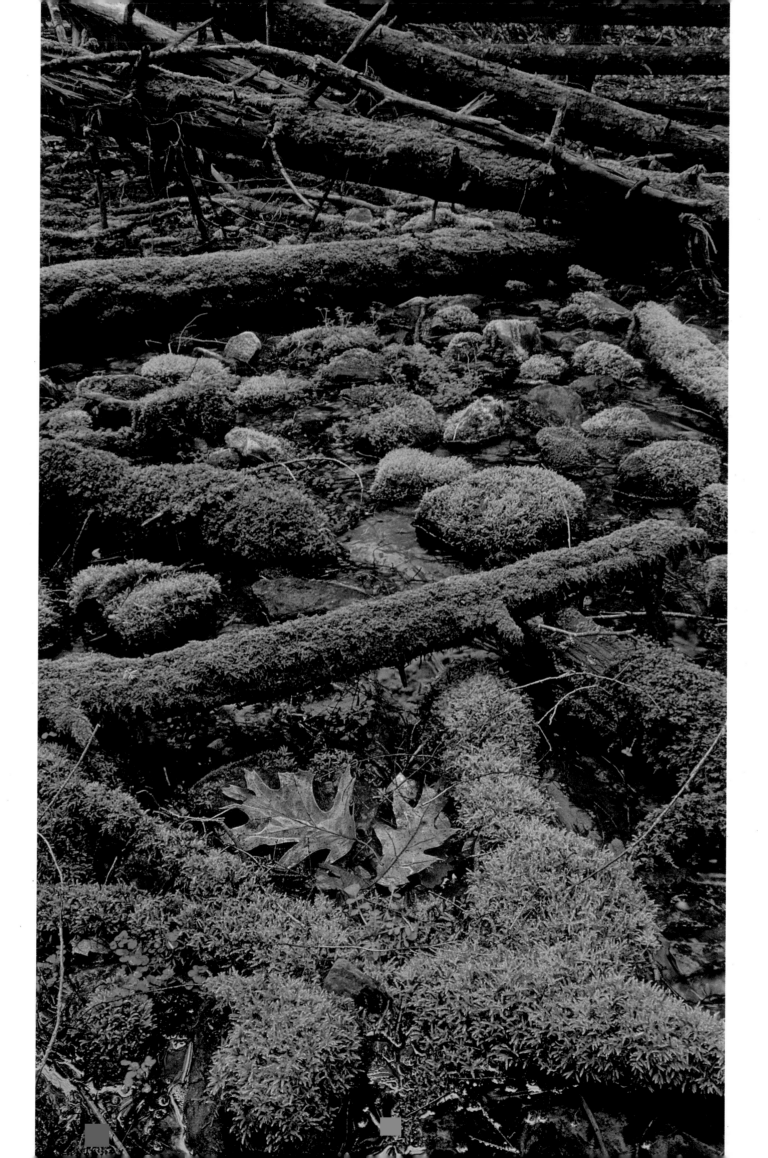

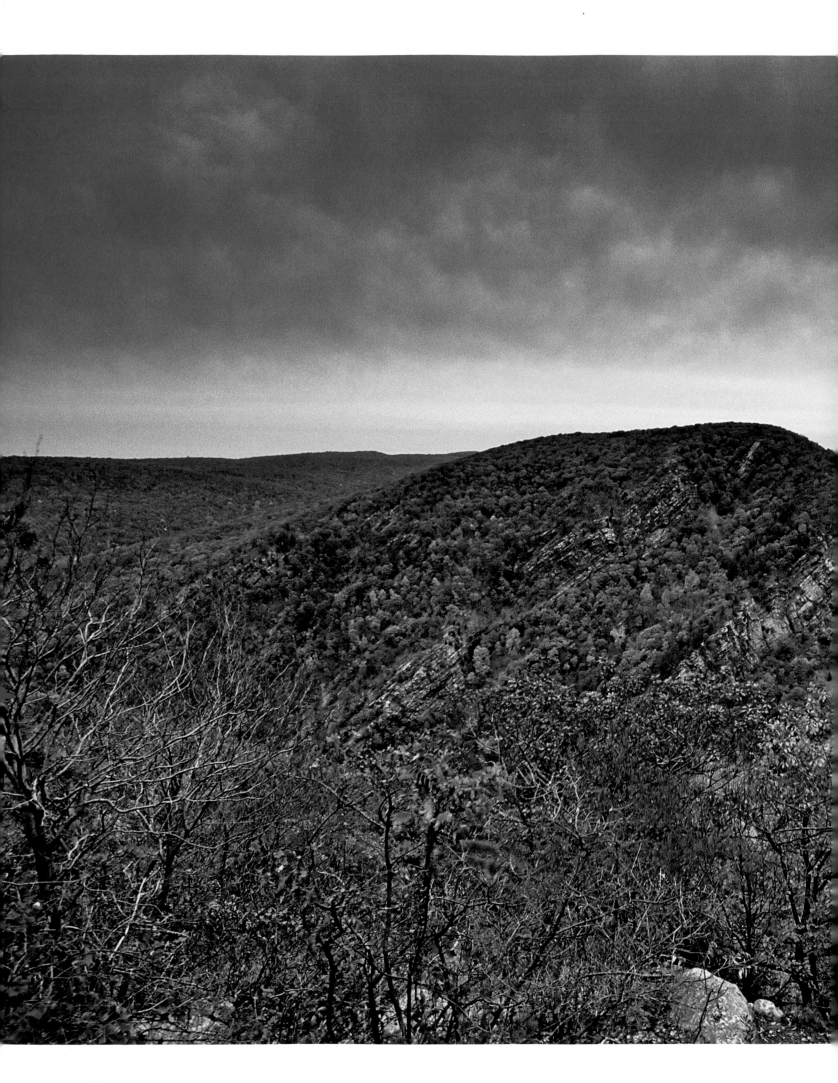

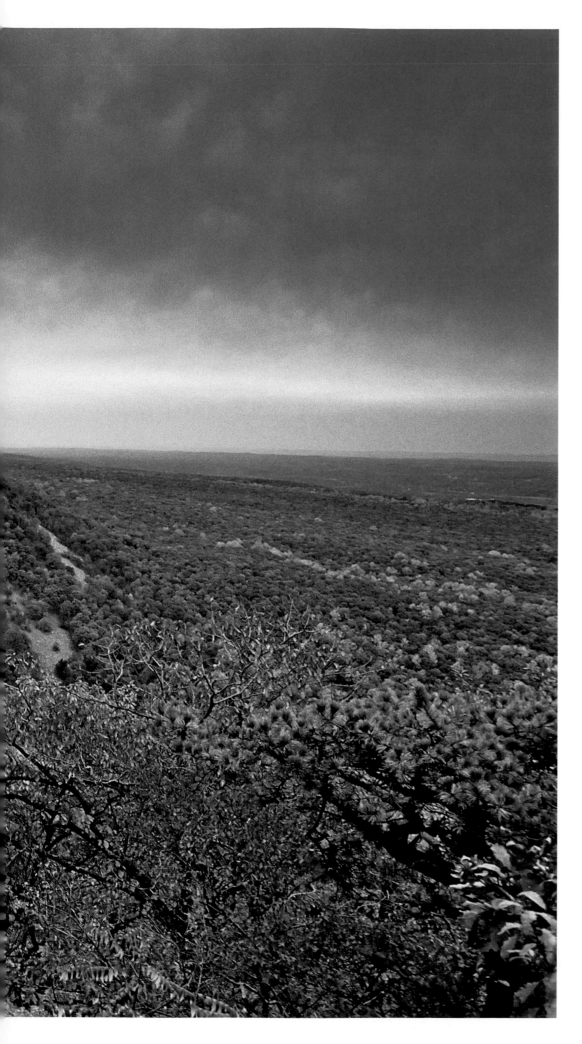

At an elevation of 1,527 feet, the top of Mount Tammany surveys its kingdom in the Delaware Water Gap.

A limestone plateau in the Kittatinny Mountains offers breathtaking views of the Stokes State Forest below.

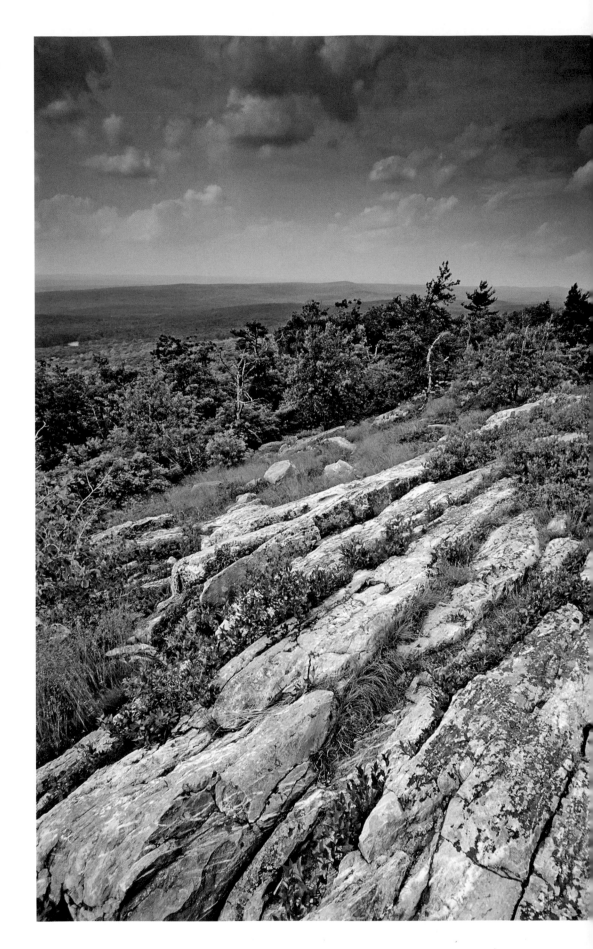

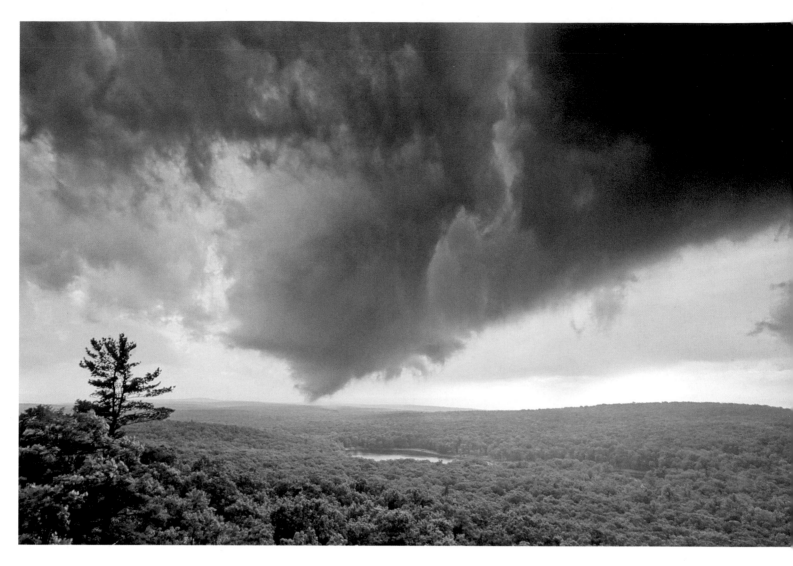

ABOVE

A rare tornado touches down on the Kittatinny Mountains, uprooting large trees at High Point State Park.

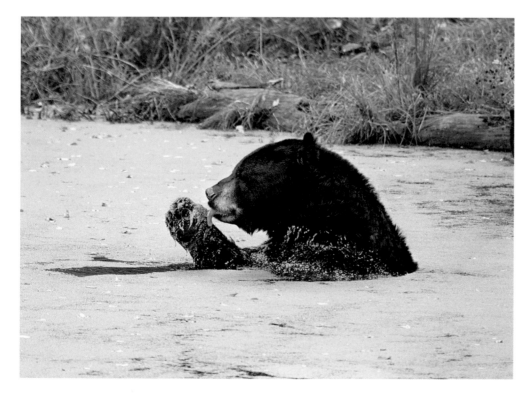

LEFT

Trying to beat the oppressive summer heat, a black bear in Warren County takes a cooling dip in a favorite pond while eating the floating duckweed.

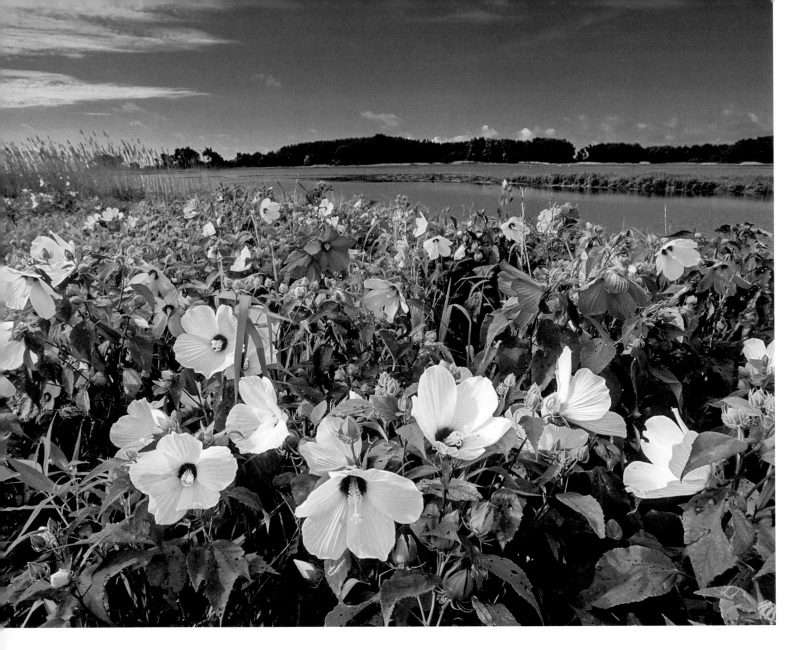

Blooming marsh-mallow wildflowers become the icing on the cake at Mannington Meadows in summer.

Even the largest oak tree in the forest is no match for this industrious beaver. The smallest leak in their dam is enough to make these furry creatures work tirelessly to find the hole and repair it. The front teeth, called incisors, never wear out because they keep growing throughout the animal's life.

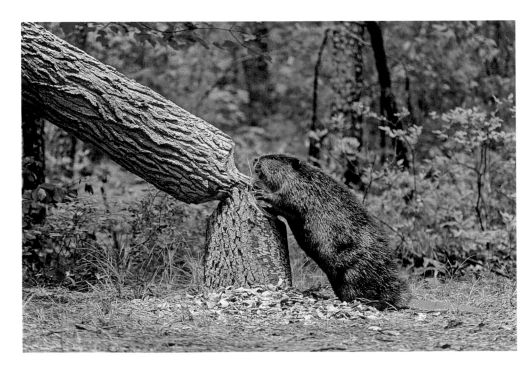

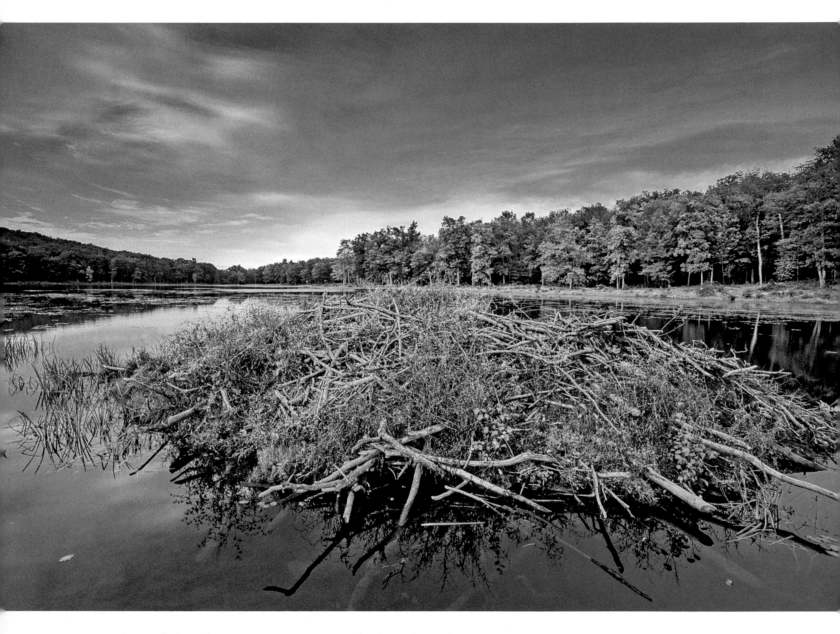

An active beaver lodge takes center stage on Sawmill Lake in the Stokes State Forest.

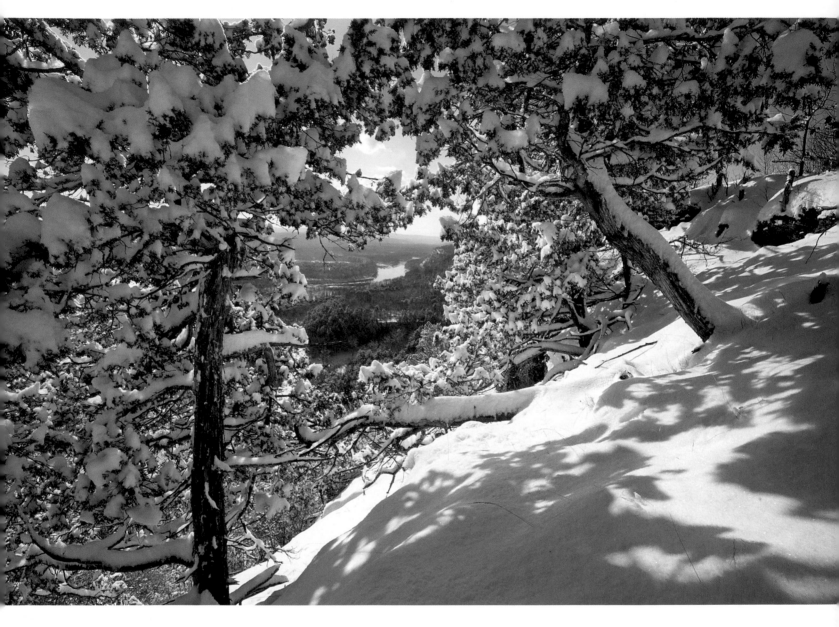

Snow-covered cedar trees overlook the Delaware River and valley in the Delaware Water Gap.

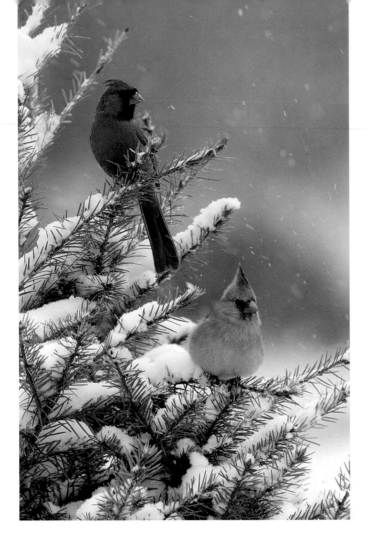

A monogamous pair of northern cardinals stay close to each other in anticipation of beginning their spring courtship rituals. This iconic North American songbird is a year-round resident in the Garden State.

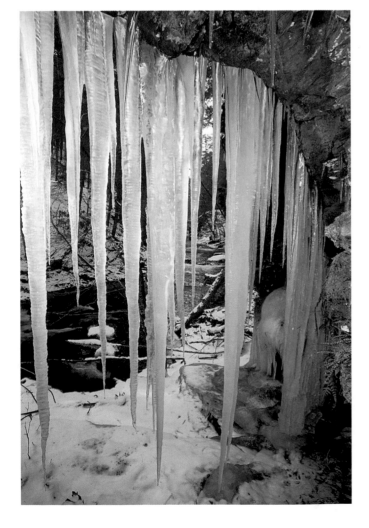

Winter's grip manifests itself into massive icicles on a limestone overhang near Dunnfield Creek in the Delaware Water Gap.

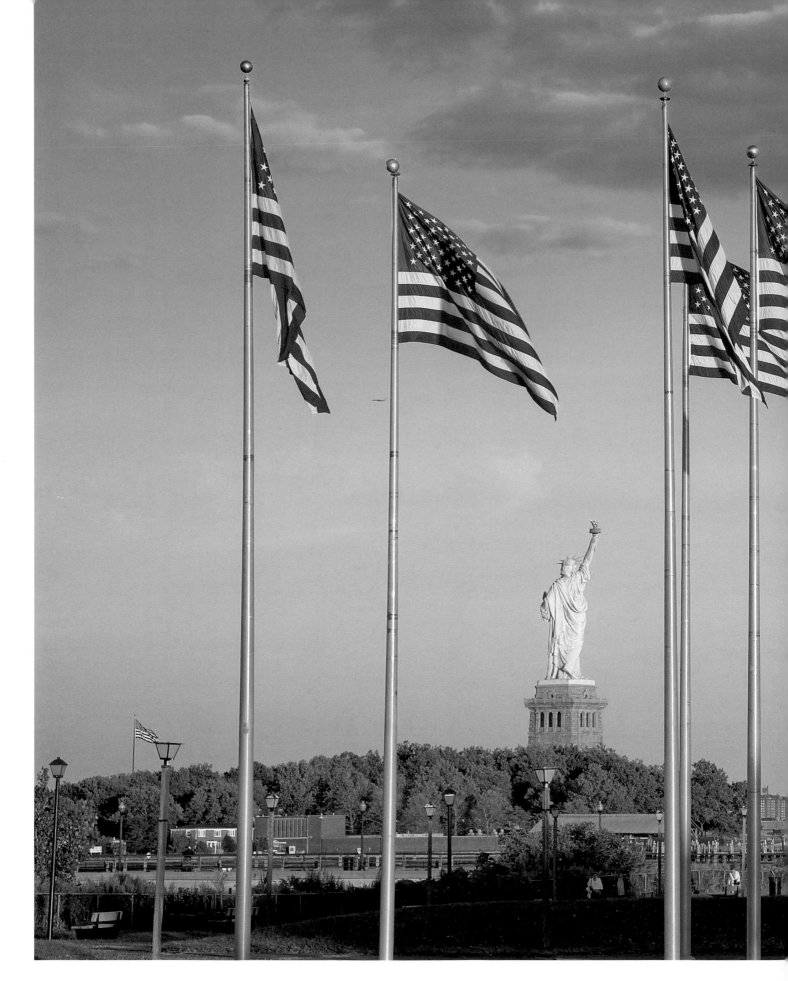

From Liberty State Park in Jersey City, the Statue of Liberty can be seen overlooking New York Harbor. The people of France gave the statue to the people of the United States over one hundred years ago in recognition of the friendship established during the American Revolution. Over the years, the Statue of Liberty has come to represent freedom and democracy as well as this international friendship.

An oil refinery off the New Jersey Turnpike becomes an iconic landmark as over 655,000 vehicles drive by each day. With over twelve lanes of highway traffic in some stretches and spanning 148 miles in length, the turnpike is the gateway between Delaware and New England.

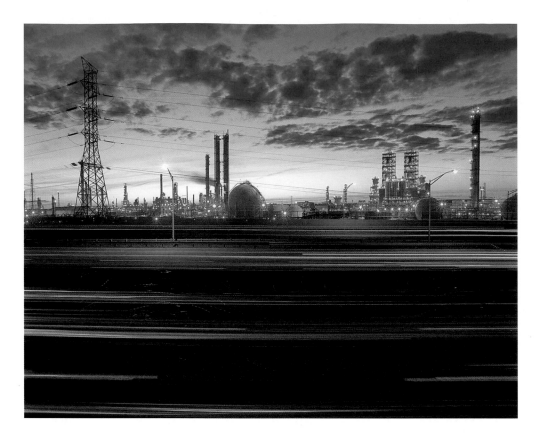

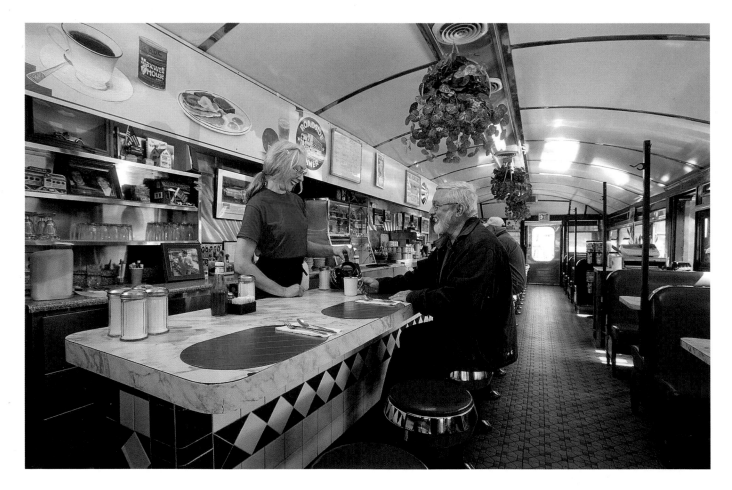

A customer orders a "blonde with sand," otherwise known as coffee with cream and sugar. The quintessential 1930s Roadside Diner in Wall Township is one of the last remaining all-original New Jersey diners. Still in the same location all these years, this restaurant's narrow design is based on the dining cars used for railway passengers.

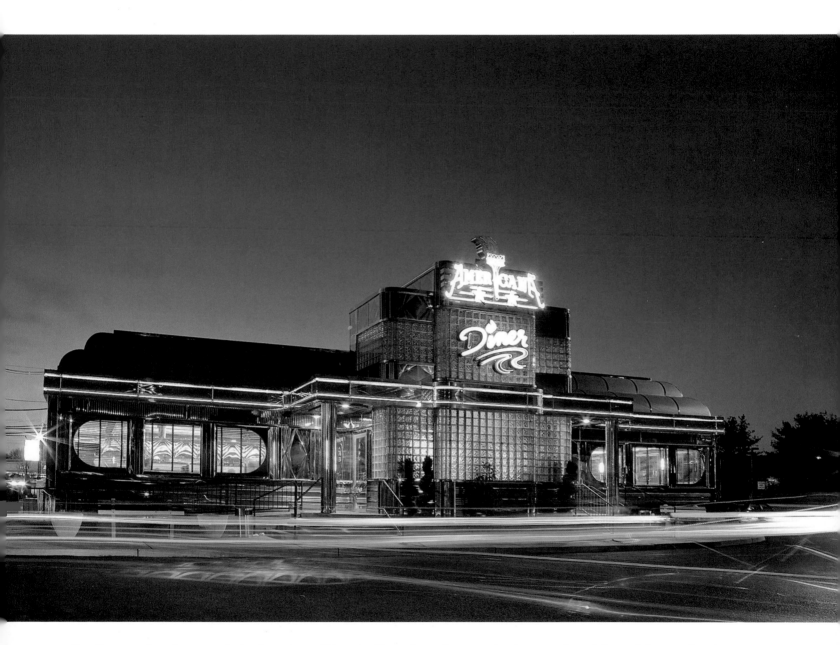

Family owned and operated, the Americana Diner in Shrewsbury features classic examples of the stainless steel and neon elements found in Art Deco architecture.

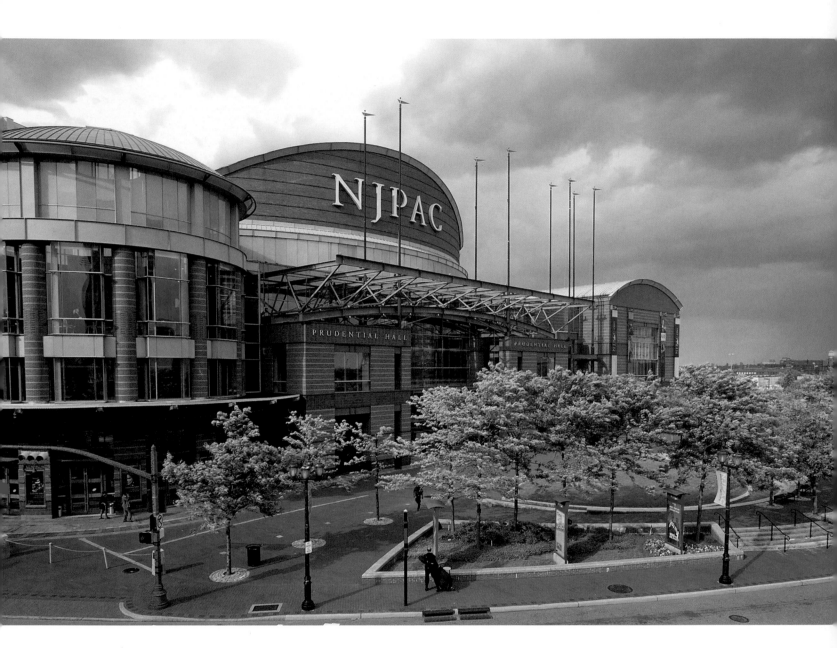

The New Jersey Performing Arts Center in Newark is the sixth-largest performing arts center in the United States. Home of the Grammy Award–winning New Jersey Symphony Orchestra, NJPAC has been widely responsible for the revitalization of New Jersey's largest city, attracting over five million visitors in its first ten years of operation.

More than two thousand cherry trees bloom each April at Branch Brook Park in Essex County. Recognized as the first county park open to the general public, the annual Cherry Blossom Festival attracts over ten thousand people a day.

Musical director Neeme Jarvi conducts the New Jersey Symphony Orchestra at the New Jersey Performing Arts Center in Newark. The breathtaking 2,750-seat Prudential Hall, classical in form and spirit, is the perfect venue to enjoy concerts of all genres.

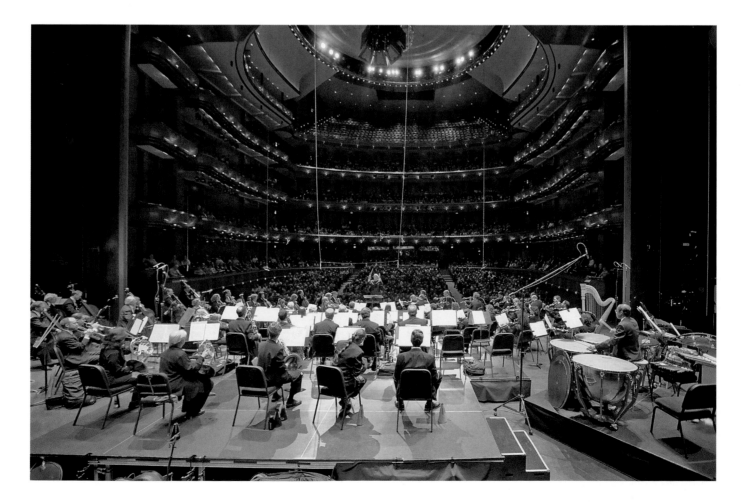

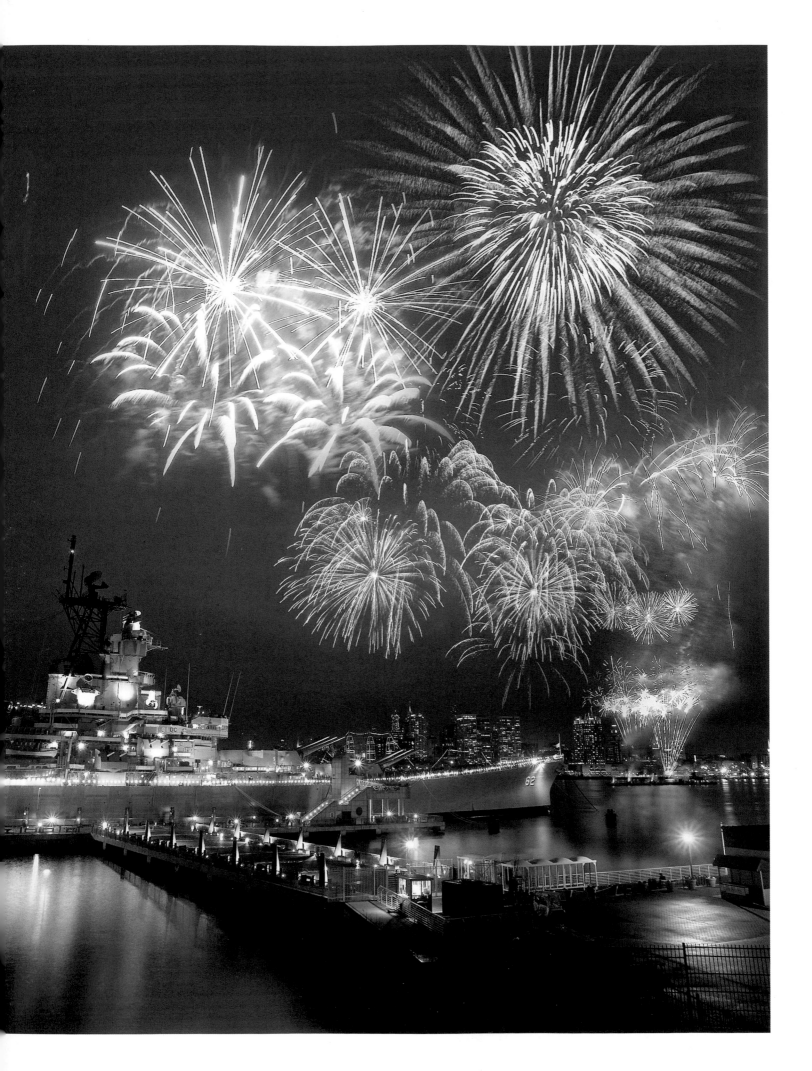

Along the Camden waterfront, New Year's Eve revelers enjoy the fireworks aboard the USS *New Jersey*. As America's most decorated battleship, *New Jersey* is famous for having earned nineteen battle and campaign stars for combat operations during World War II, the Korean War, the Vietnam War, the Lebanese Civil War, and service in the Persian Gulf. She is now a floating museum, open for tours and events.

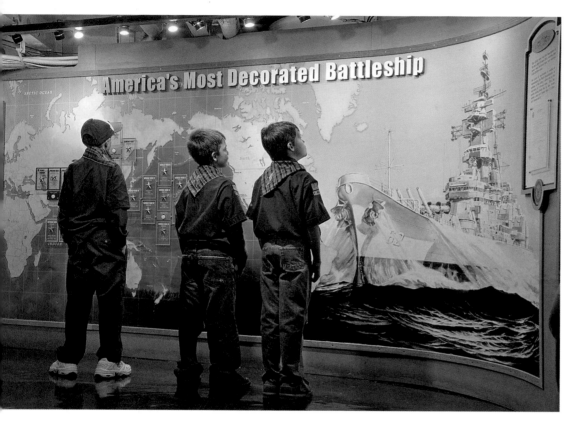

LEFT

At the Camden waterfront, cub scouts aboard the USS *New Jersey* learn about the battleship's history.

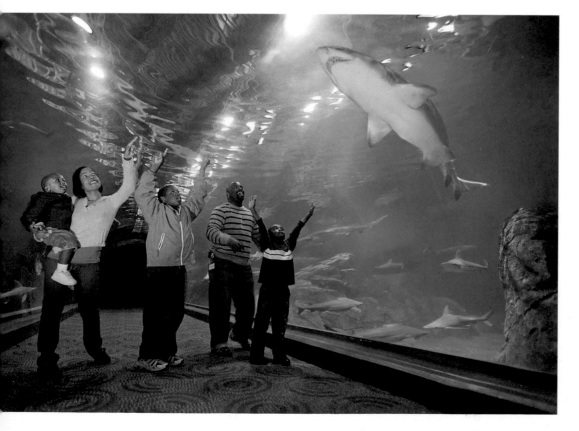

LEFT

The thrill of standing in an underwater tunnel at the Adventure Aquarium in Camden is the closet you can get to a sand tiger shark, without getting wet.

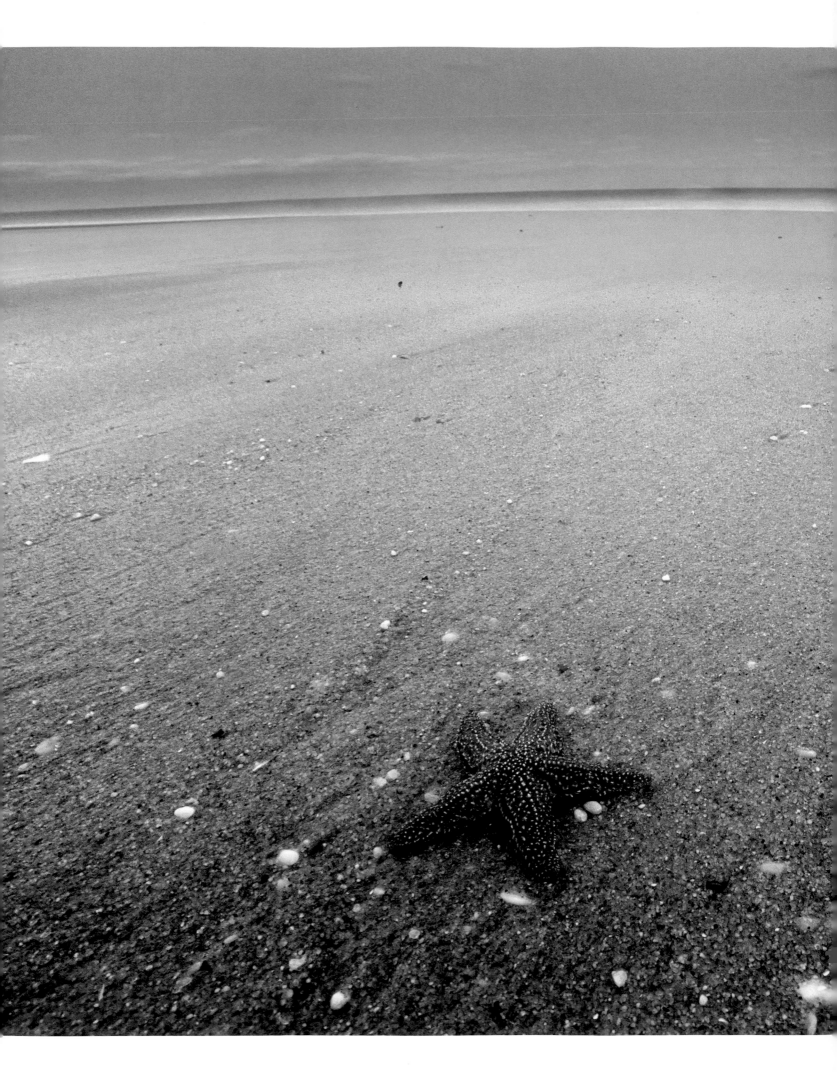

The rolling surf from the incoming tide ejects a starfish at Seabright Beach. As it waits for the next wave to rejoin its ocean home, this marine animal becomes vulnerable to the appetites of shorebirds.

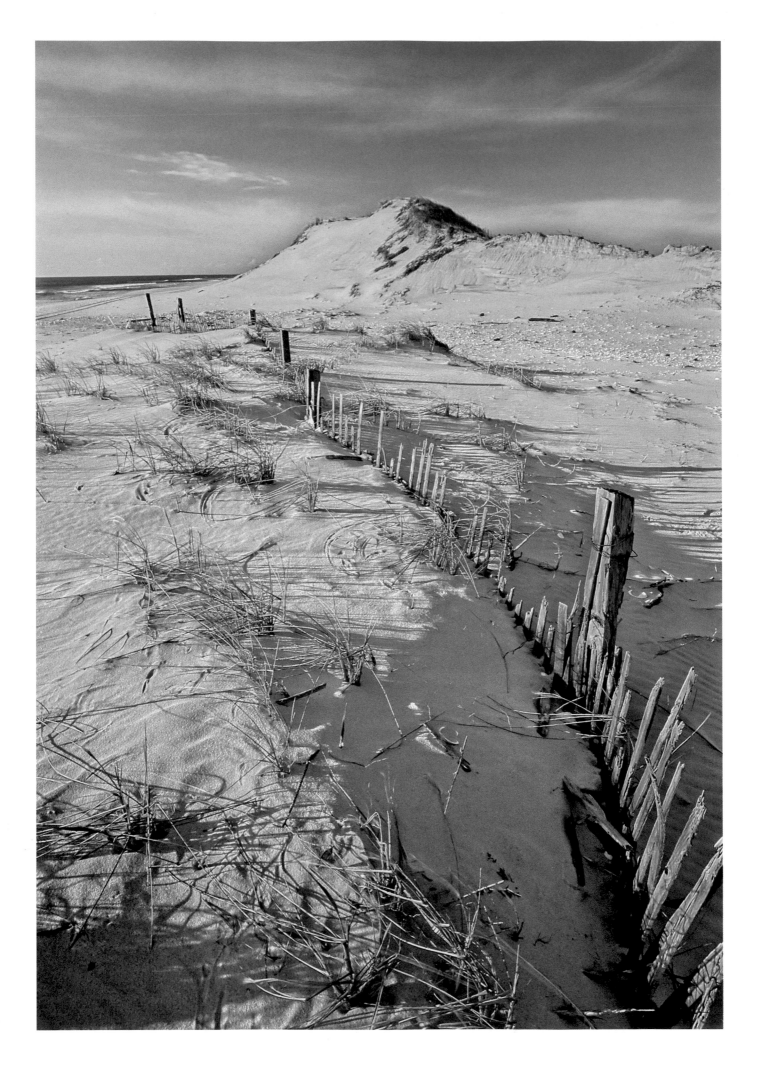

OPPOSITE
Sand-dune fencing is the backbone to providing stability to the ever-shifting sand at the Island Beach State Park barrier island.

LEFT
A yacht navigates around the Great Beds Lighthouse in Raritan Bay near Perth Amboy. Sailing is more than a recreational pastime here; it's a passion.

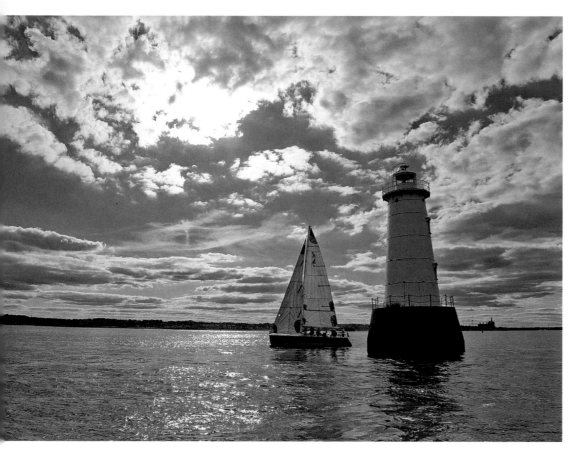

RIGHT
When food is scarce in the Canadian Arctic, the snowy owl can be a rare winter visitor along the coastal grasslands in New Jersey.

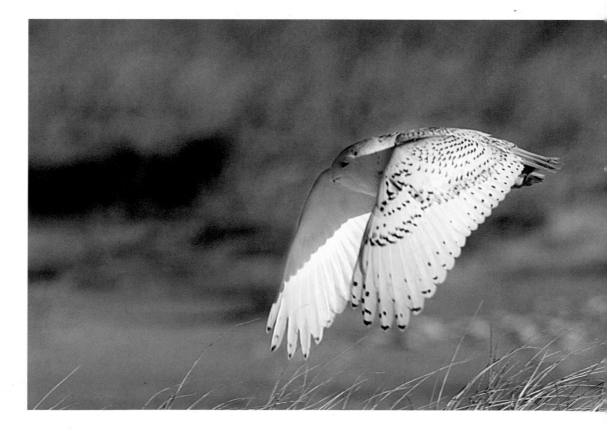

35

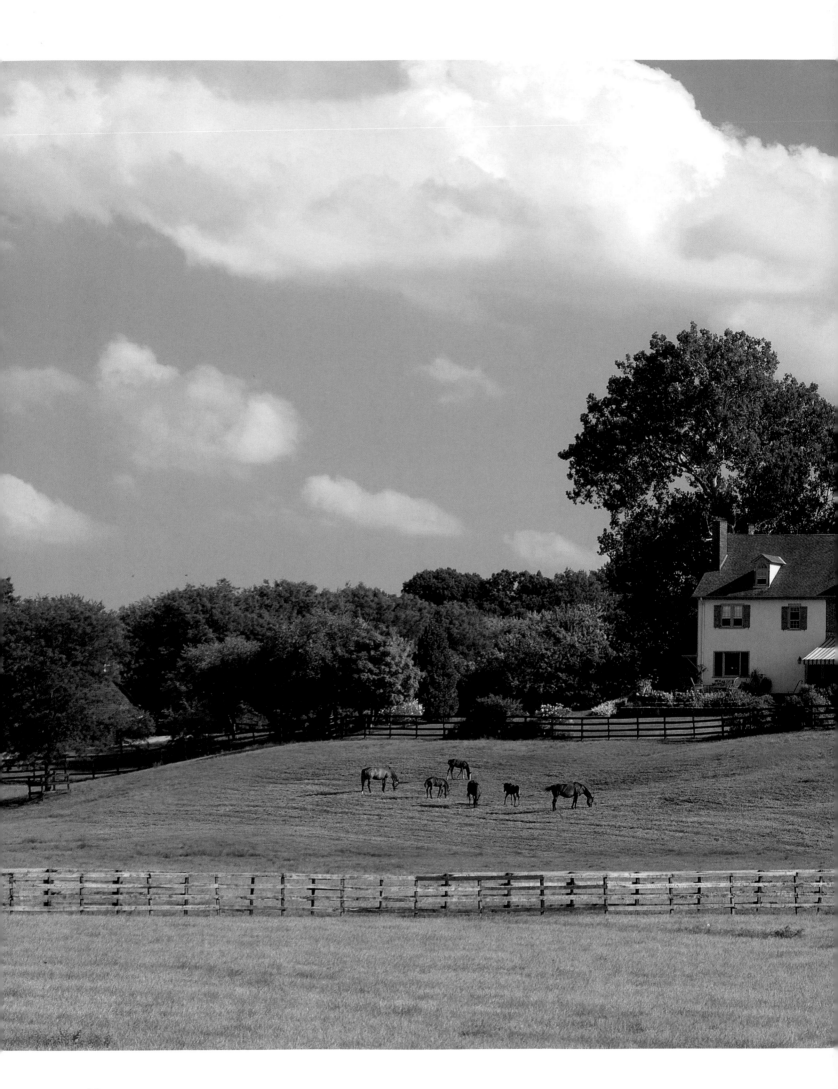

LEFT

New Jersey has more horses, horse farms, and horse breeders than Kentucky. Brightview Farm is a quintessential example of our state's rich racing tradition.

BELOW

A mare and her foal stretch their legs at Brightview Farm.

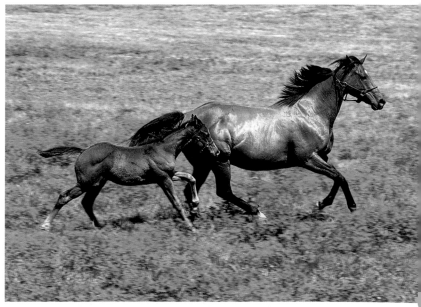

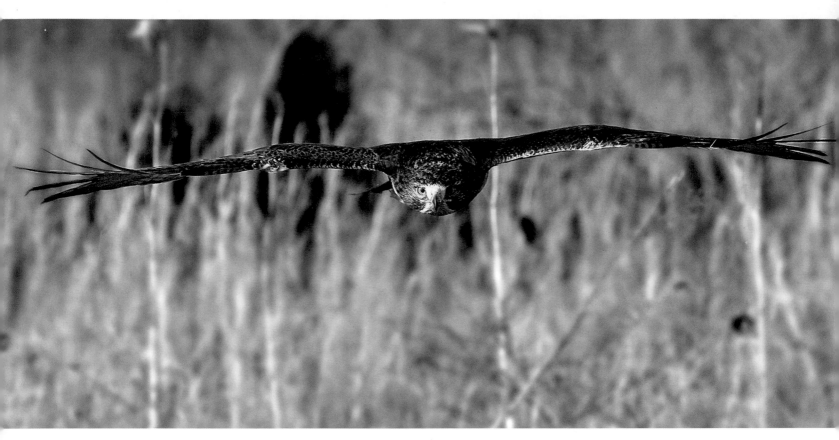

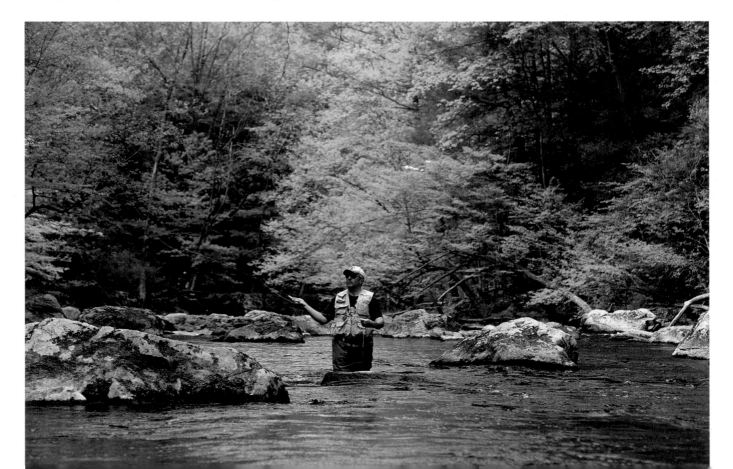

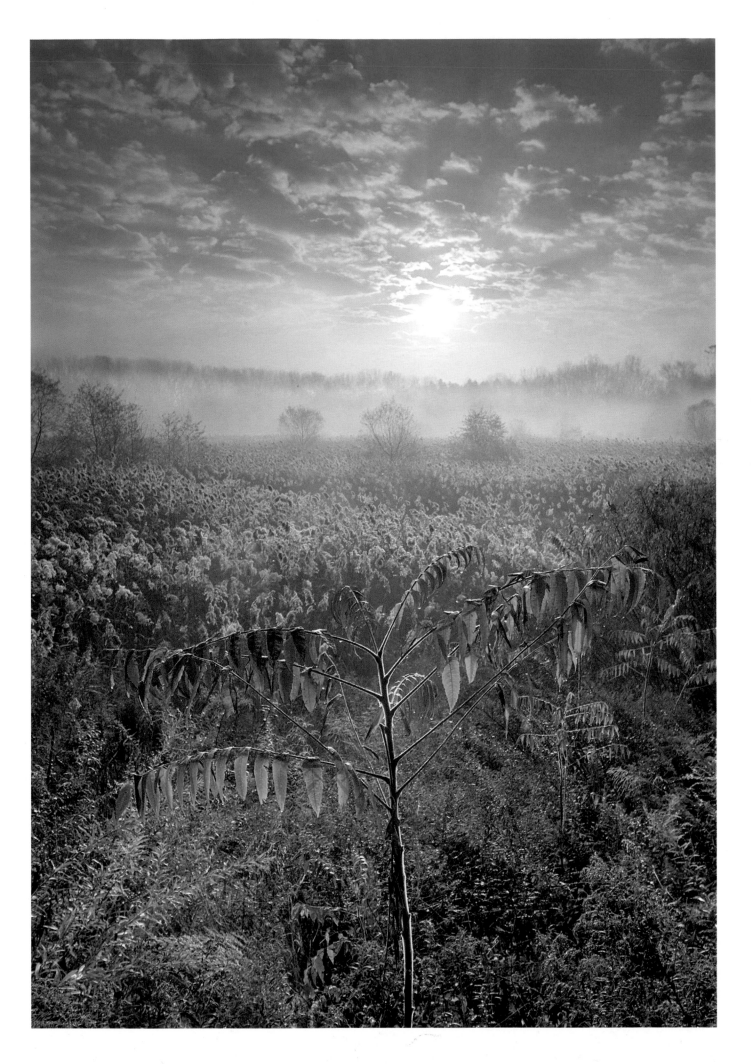

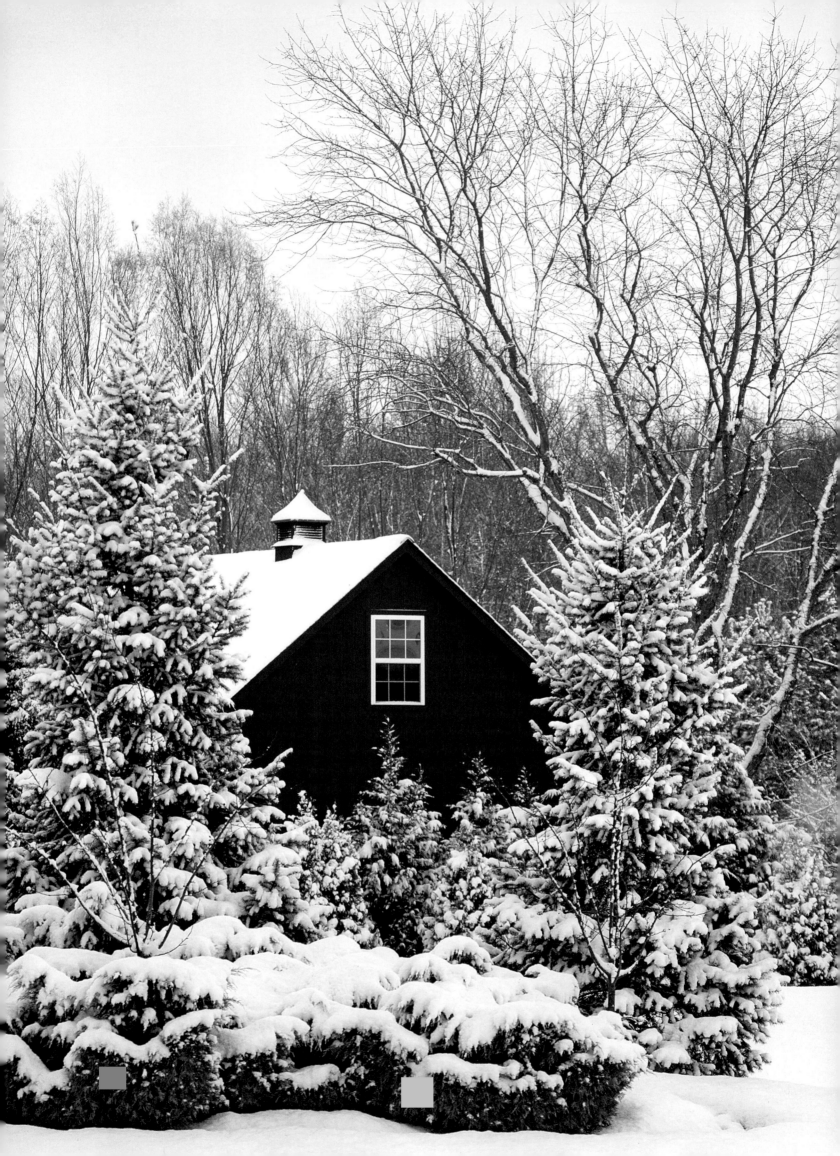

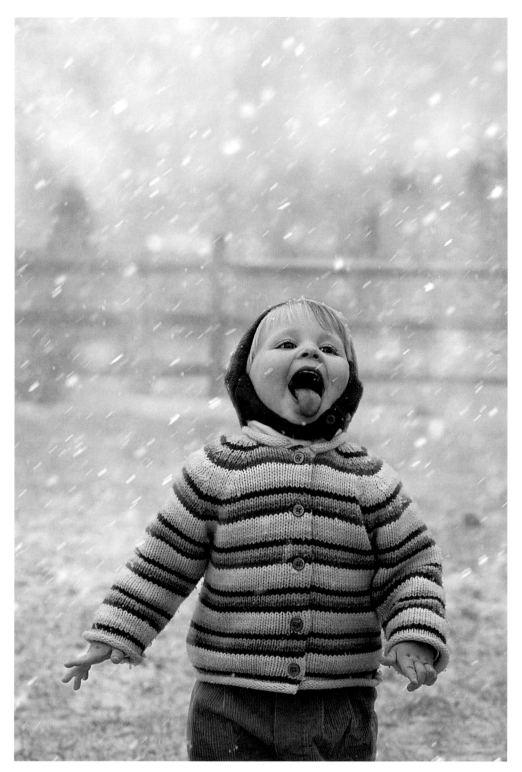

The youthful exuberance of catching the first snowflakes of winter celebrates the change in seasons.

The crisp stillness from a new blanket of snow covers a farmhouse in Mount Laurel.

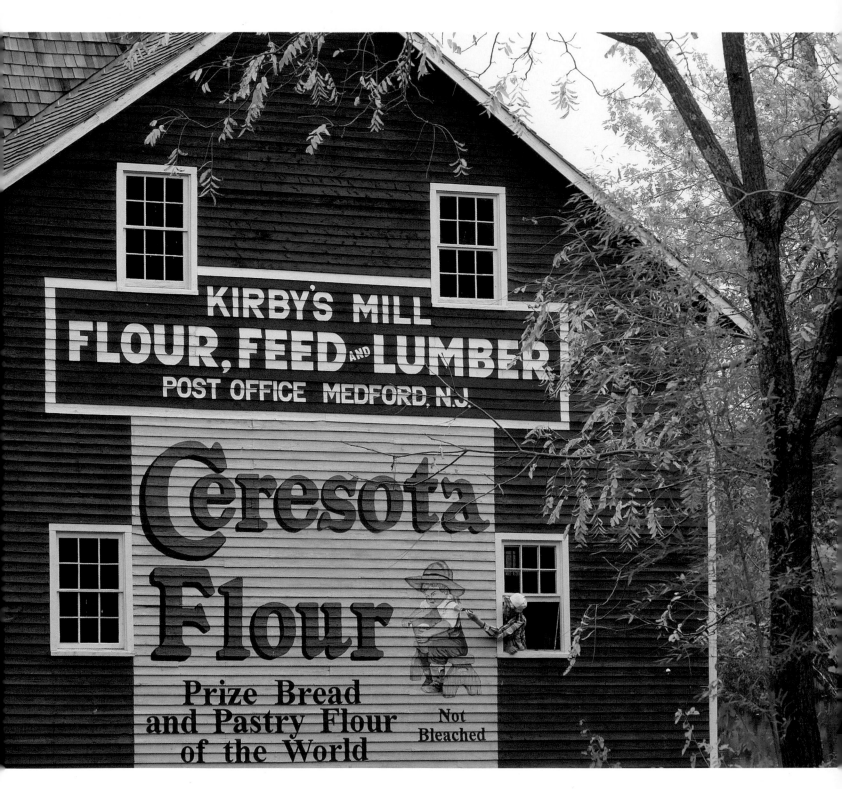

Originally a flour and saw mill in the 1800s, Kirby's Mill has been painstakingly restored to its original condition. Now owned by the Medford Historical Society, it has been entered in the National Register of Historic Places.

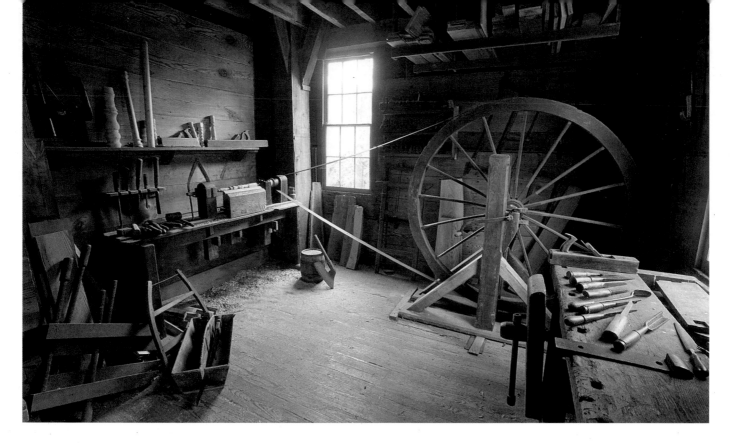

ABOVE

A restored carpentry mill can be found in historic Kirby's Mill.

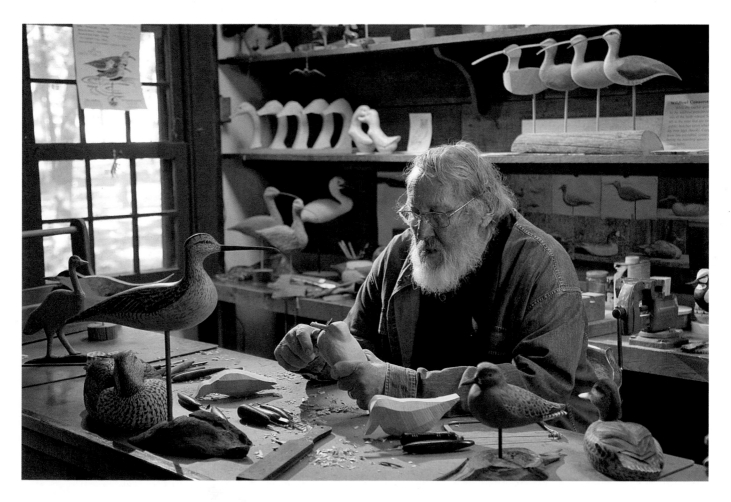

ABOVE

Living legend Jim Seibert is an award-winning duck-carving artist with worldwide demand for his creations. He resides in Dennisville.

In the nineteenth century, an army colonel stood before a crowd at the Salem County Courthouse and ate buckets of tomatoes to prove that they were not poisonous. Ever since, the red vegetable of summer (actually a fruit) has played a starring role in New Jersey's agricultural history. Today the Garden State's legacy of agriculture extends far beyond the homegrown pride of the Jersey tomato.

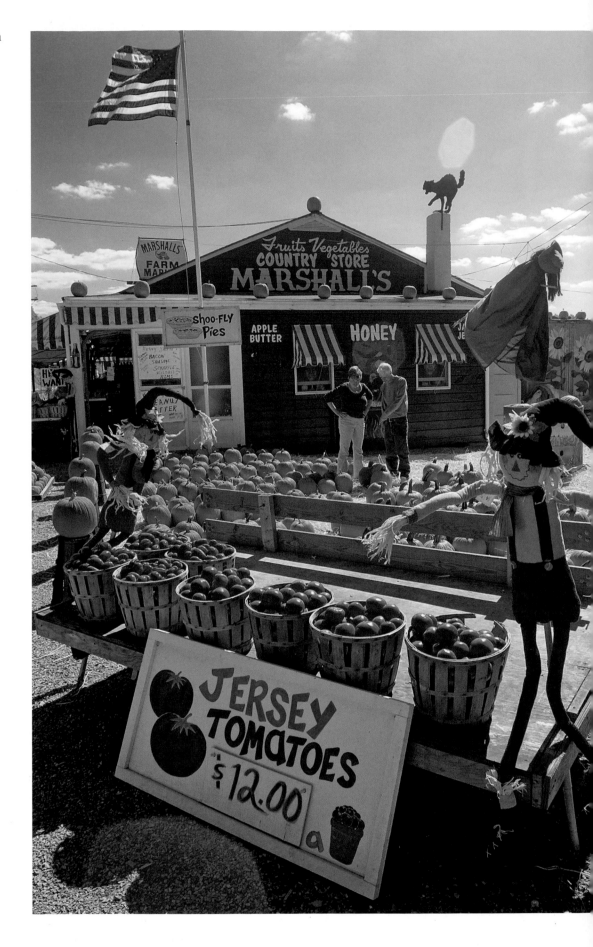

Children pick pumpkins at Springdale Farm in Cherry Hill.

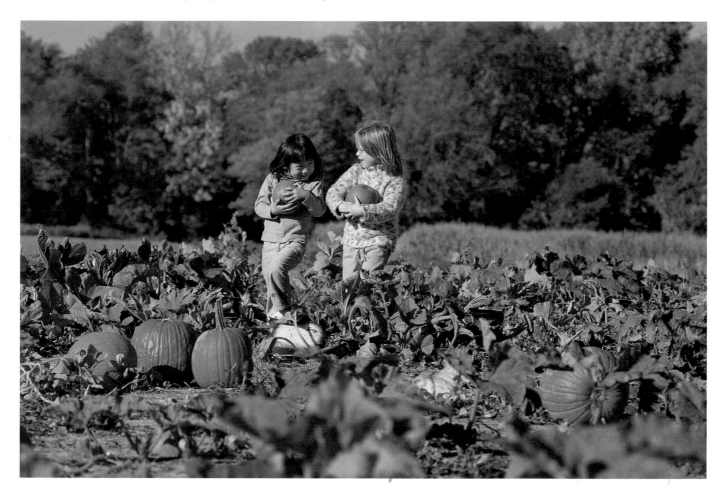

Constructed in 1750 and spanning rocky Wickecheoke Creek, Green Sergeant's Covered Bridge in Hunterdon County is the only remaining public-accessible covered bridge in New Jersey.

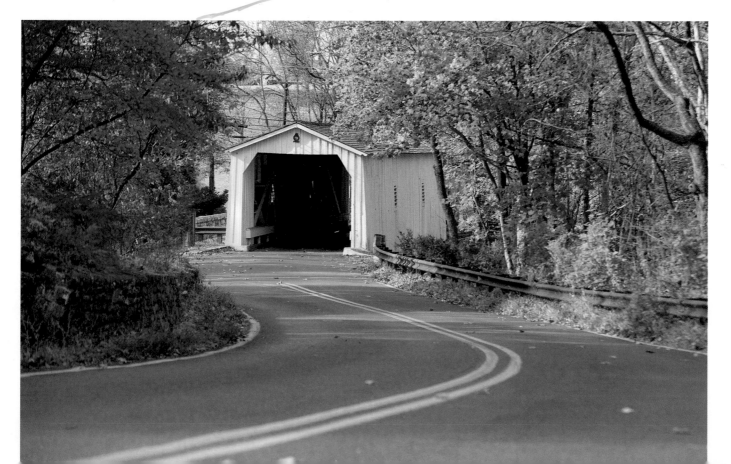

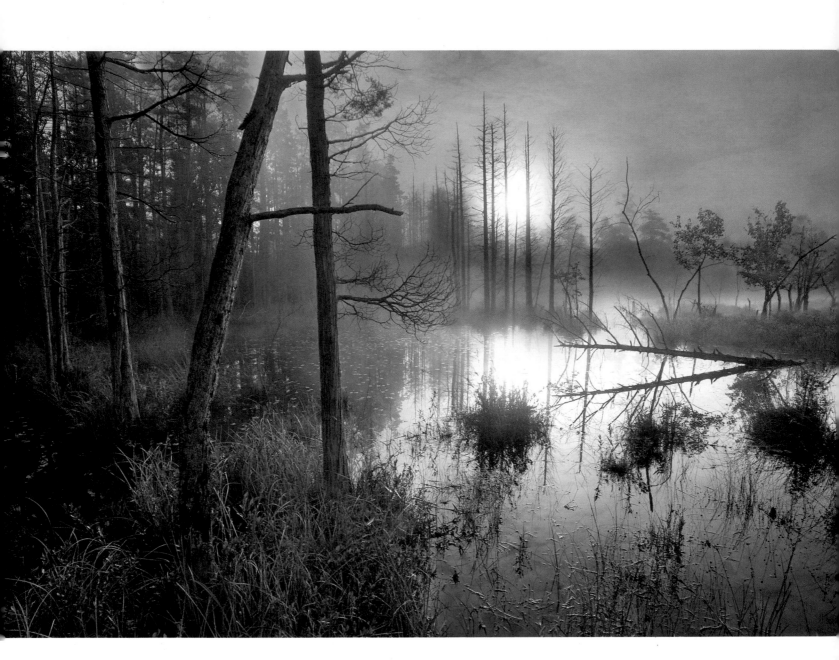

A predawn fog gives way to a gentle and misty sunrise along the upper Mullica River.

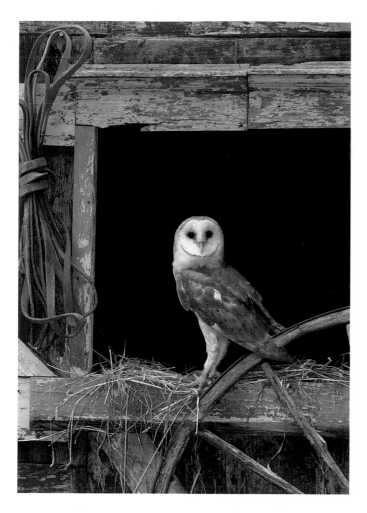

The barn owl is one of New Jersey's best natural mousetraps. Consuming one and a half times their weight in meadow voles and rats each day, these monkey-faced owls are welcome residents on farmland.

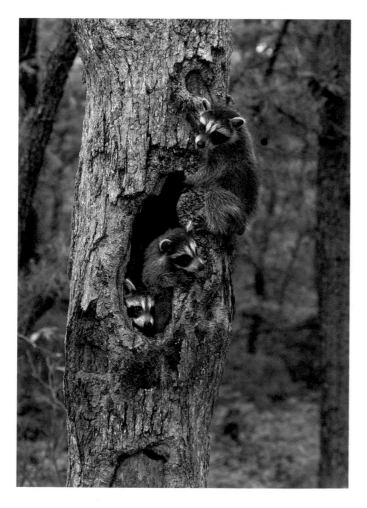

Curious by nature, baby raccoons begin venturing from the safety of home to explore their new world.

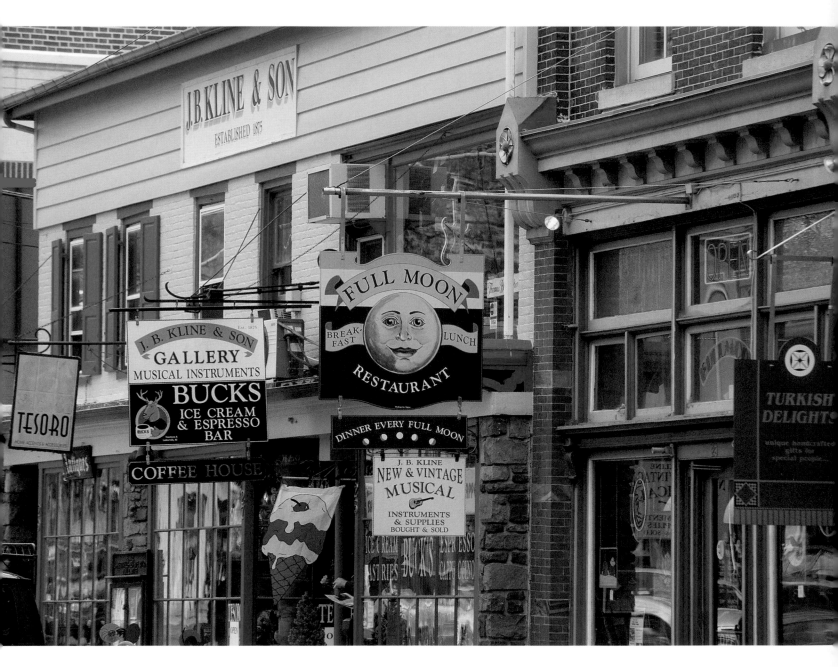

Known as the antique capital of New Jersey, Lambertville has an eclectic mix of specialty stores with everything from French linens to Greek ceramics to contemporary American crafts.

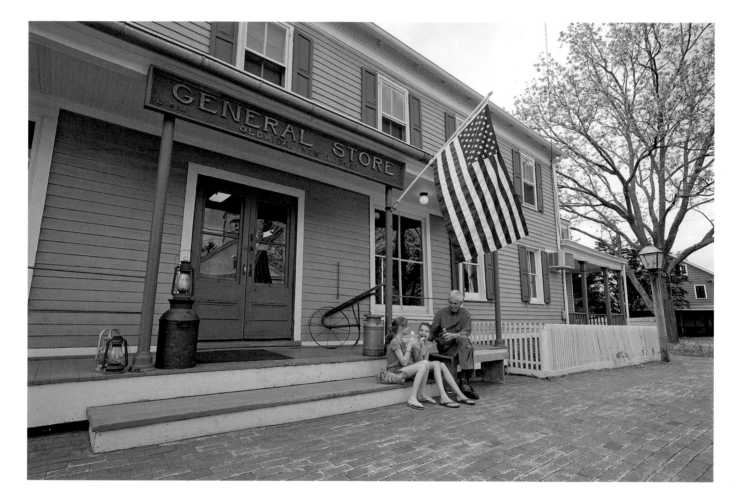

The historic Oldwick General Store, built circa 1750, is still selling its goods today. Located in Tewksbury Township, the shop was once frequented by George Washington and his troops.

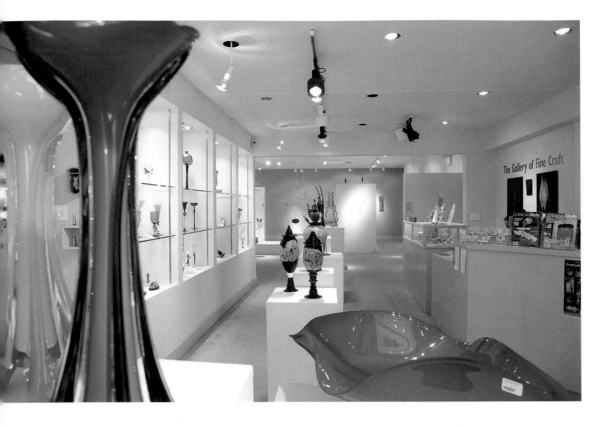

LEFT
The Wheaton Arts and Cultural Center in Millville has a gallery that helps preserve New Jersey's tradition of glassmaking by displaying unique handblown glass artwork.

RIGHT
A master glass artist turns molten glass into a pitcher at the Wheaton Arts and Cultural Center.

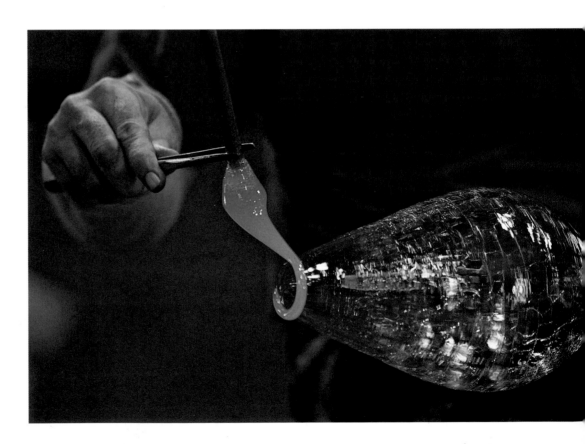

OPPOSITE
Early American glass is on display in the Museum of American Glass at the Wheaton Arts and Cultural Center.

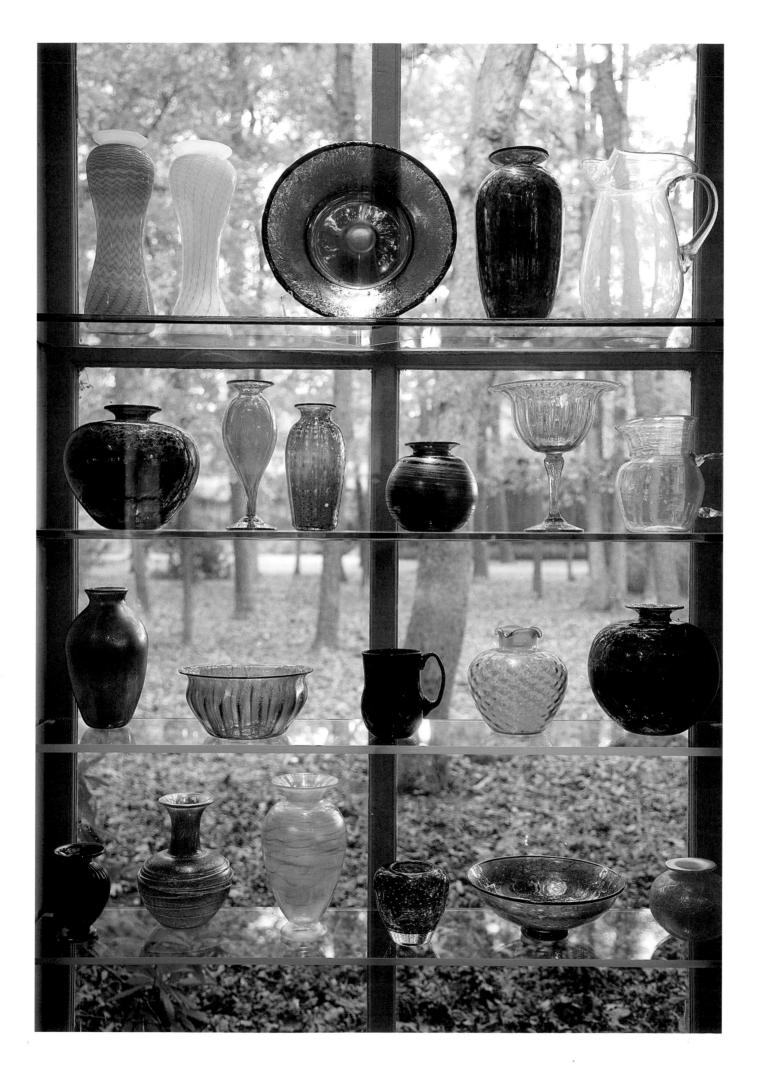

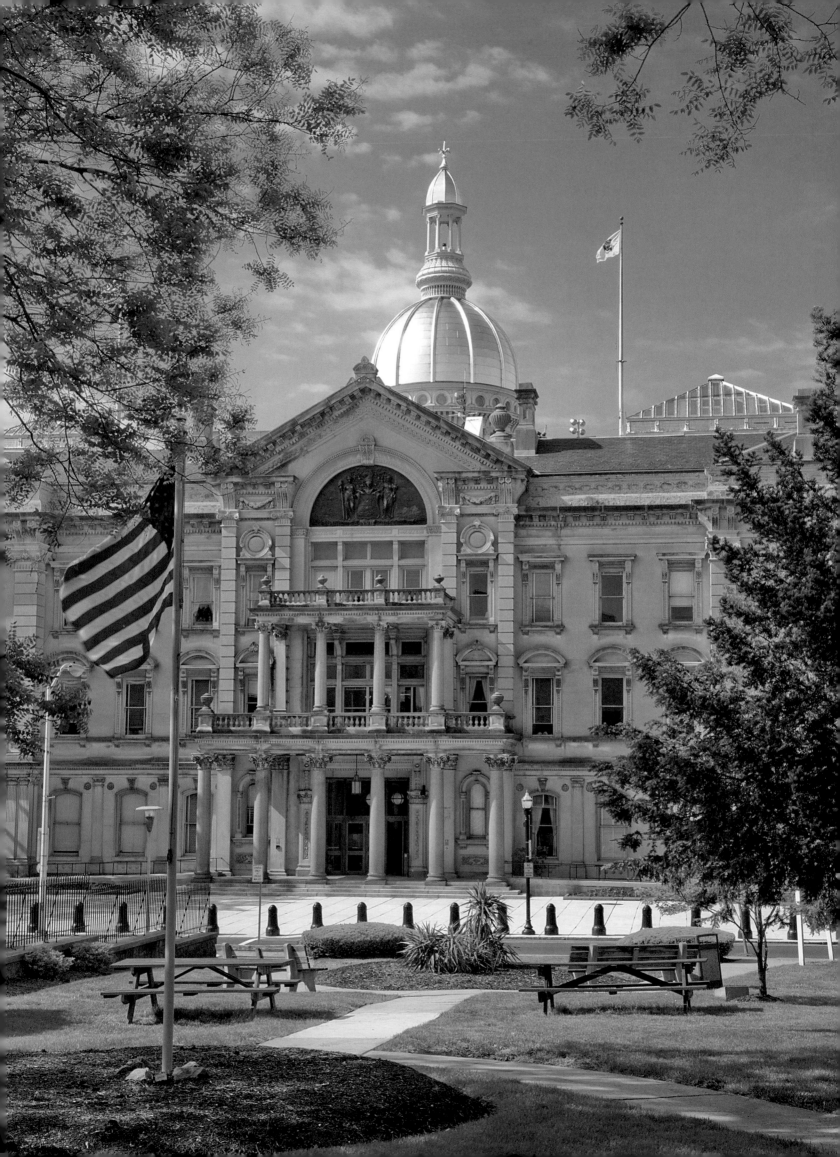

The New Jersey State House, located in Trenton, is the second-oldest state house in continuous legislative use in the United States. The iconic gold dome was recently renovated and covered with 48,000 pieces of gold leaf. Each piece of gold leaf cost one dollar and was paid for with money raised by New Jersey school kids through the "Dimes for the Dome" program. As a thank you for their contributions, the dome stands in honor of New Jersey children.

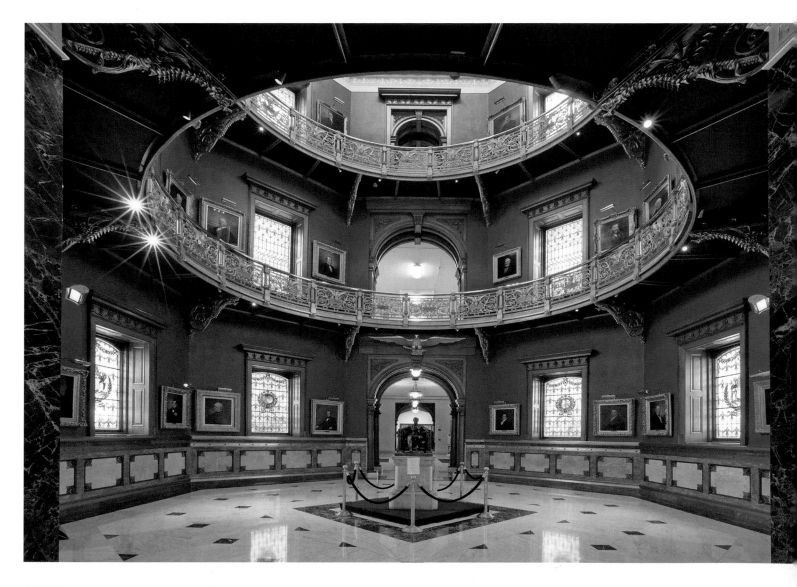

ABOVE

The historic rotunda in the New Jersey State House displays impressive stained-glass windows, flanked by portraits of our early governors. As home to our state's democratic process, the legislative building serves the citizens of New Jersey in shaping public policy.

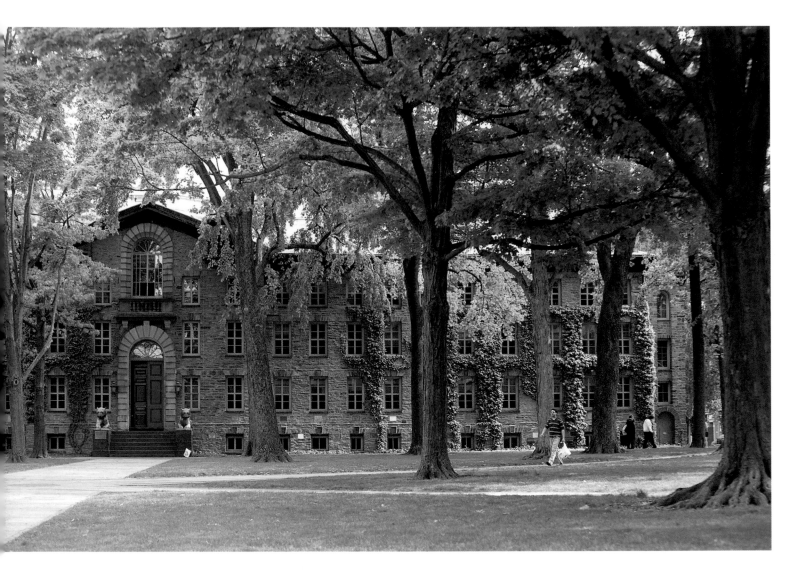

During the American Revolutionary War, Nassau Hall was held by both British and American troops, and suffered considerable damage during the Battle of Princeton in 1777. From July to October 1783, the town of Princeton was the capital of the United States, and Nassau Hall hosted the entire American government. Today, the famed building holds Princeton University's administrative offices.

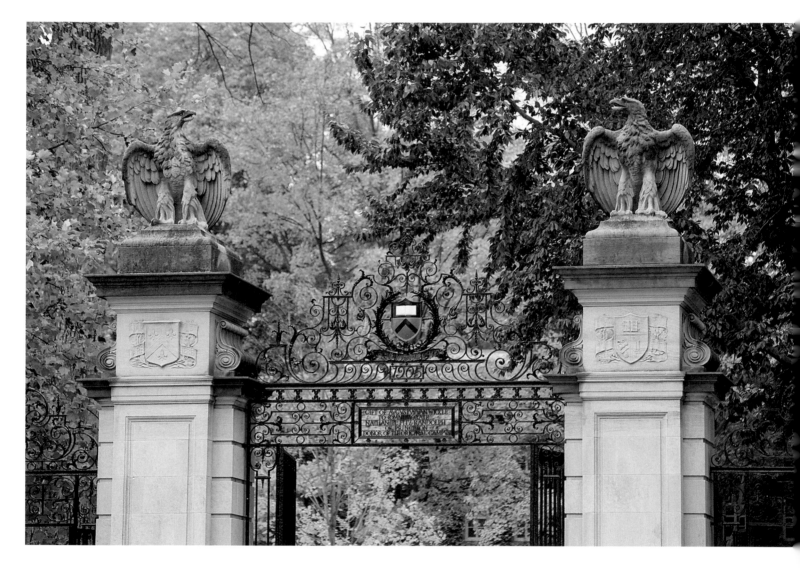

Princeton University enjoys the unparalleled reputation of being a world-class institution for higher education. From 2001 to 2008, Princeton University has been ranked first among national universities by *U.S. News and World Report*.

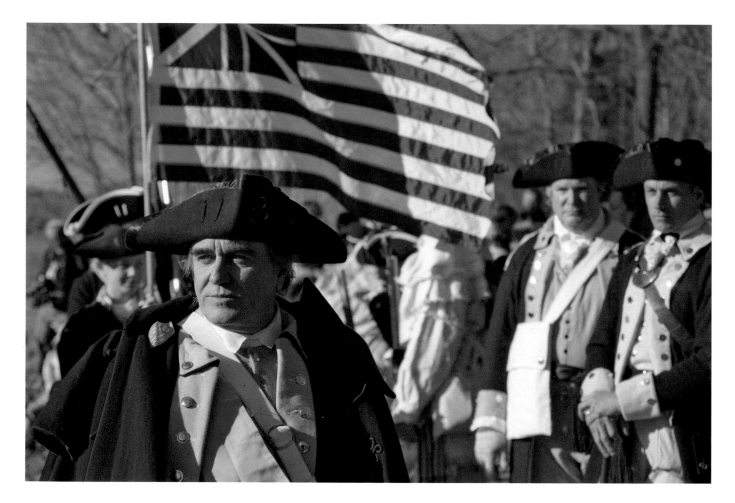

At Washington Crossing State Park, Revolutionary War reenactors tell of George Washington and the Continental Army marching toward Trenton.

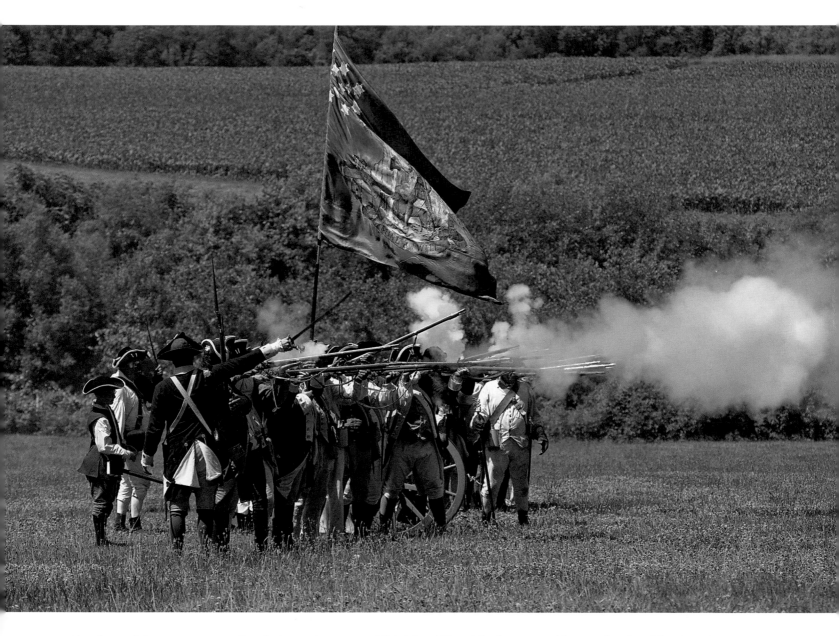

Continental Army reenactors fire their muskets toward British soldiers. The largest and longest battle of the American Revolutionary War is relived each June at Monmouth Battlefield State Park.

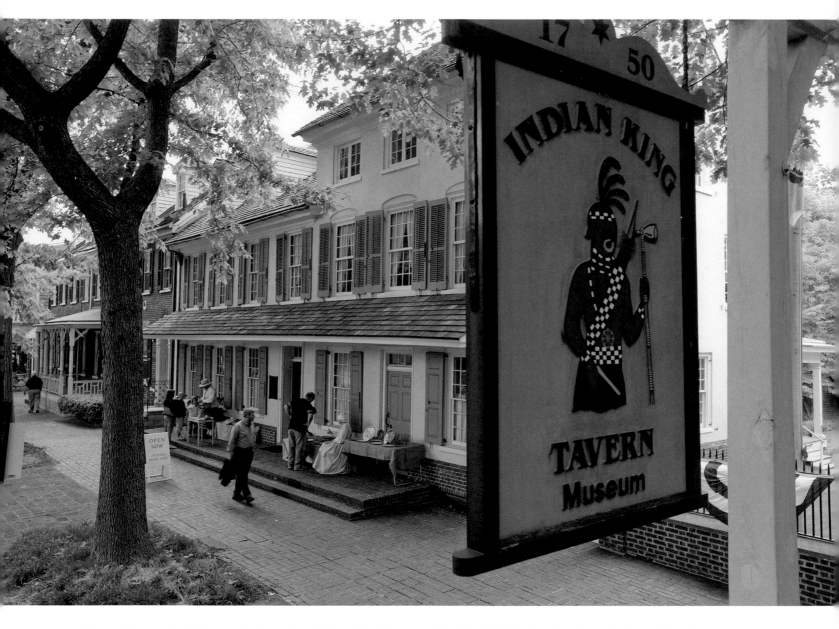

Named for the local Lenape Indians, the Indian King Tavern in Haddonfield is the site where, in 1777, New Jersey was legally declared a state. Now a historic site and museum, visitors can see where the state legislature first adopted the Great Seal of New Jersey.

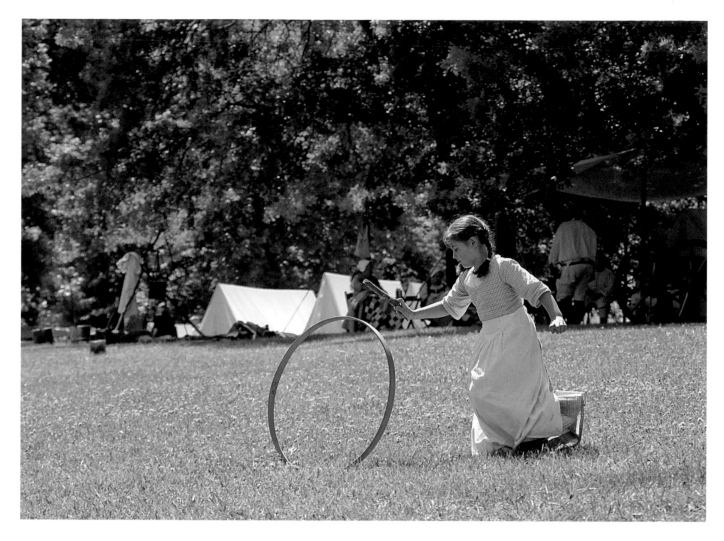

Colonial American history is portrayed by camp follower reenactors at Monmouth Battlefield State Park.

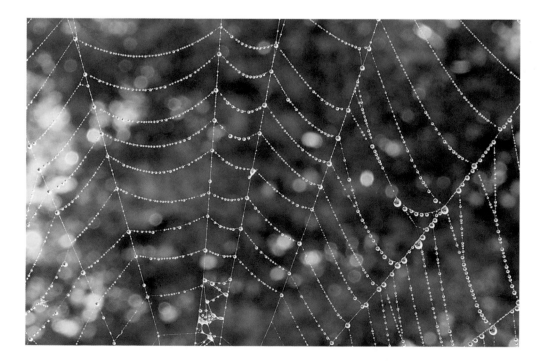

Morning dewdrops glisten on a spider's web in the stillness of a Lumberton meadow.

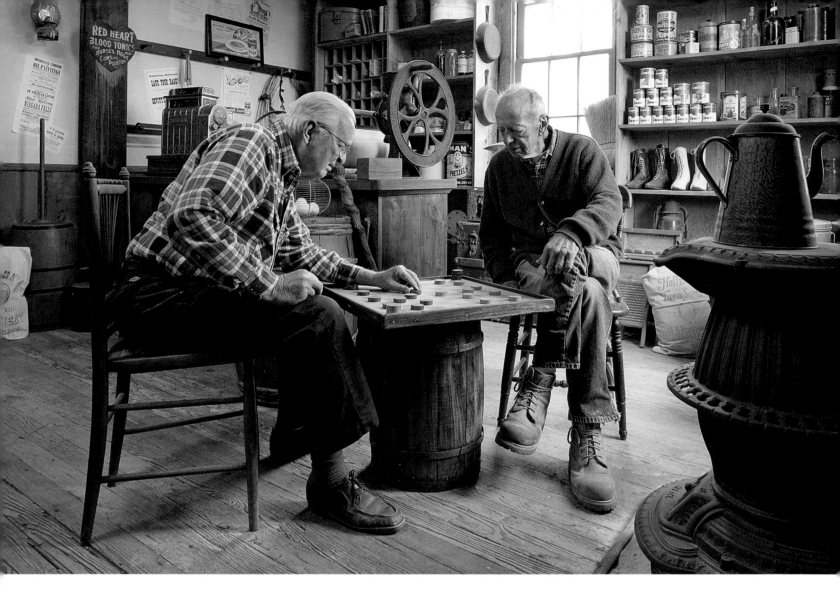

ABOVE

In a tradition going back to the 1800s, local old-timers play checkers by the wood stove in the general store at historic Kirby's Mill in Medford.

RIGHT

Mount Holly's town clock marks time on the historic town's main street. Originally formed in 1688, Mount Holly boasts many restored eighteenth- and nineteenth-century buildings listed on the National Register of Historic Places.

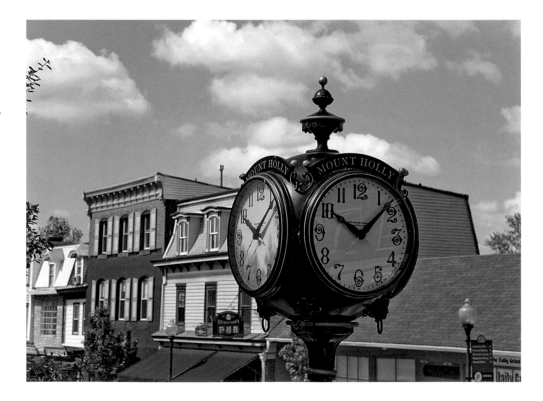

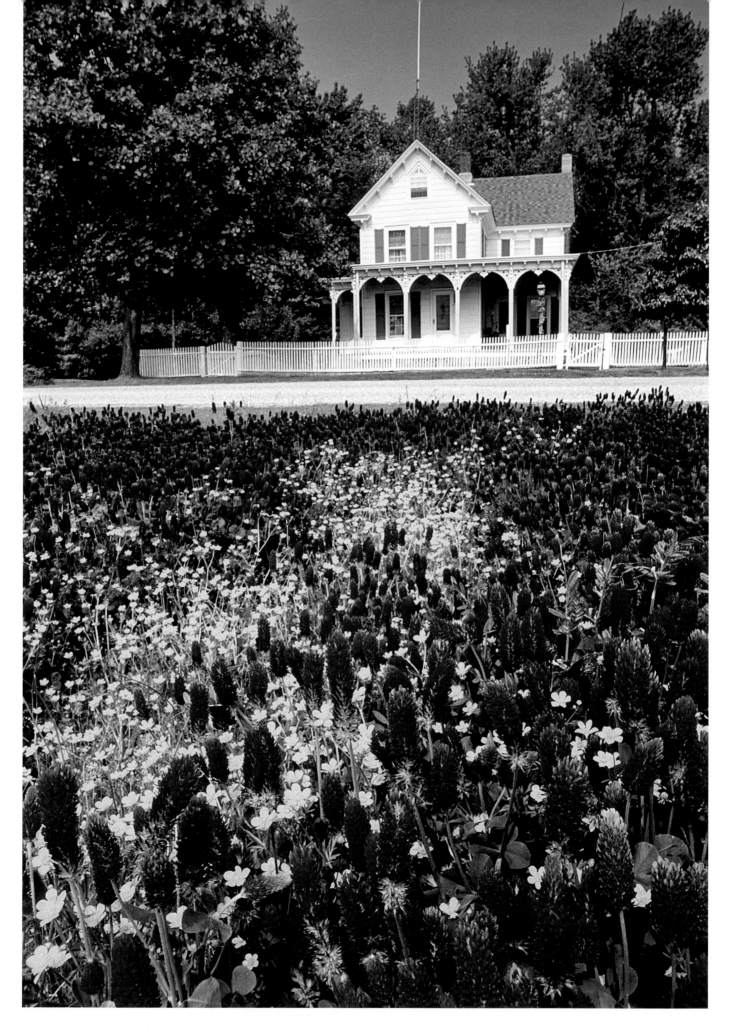

To help rejuvenate the soil in a farmer's field, it's common to plant colorful clover. The cover crop will add important nutrients and nitrogen to next year's harvest on this Cedarville farm.

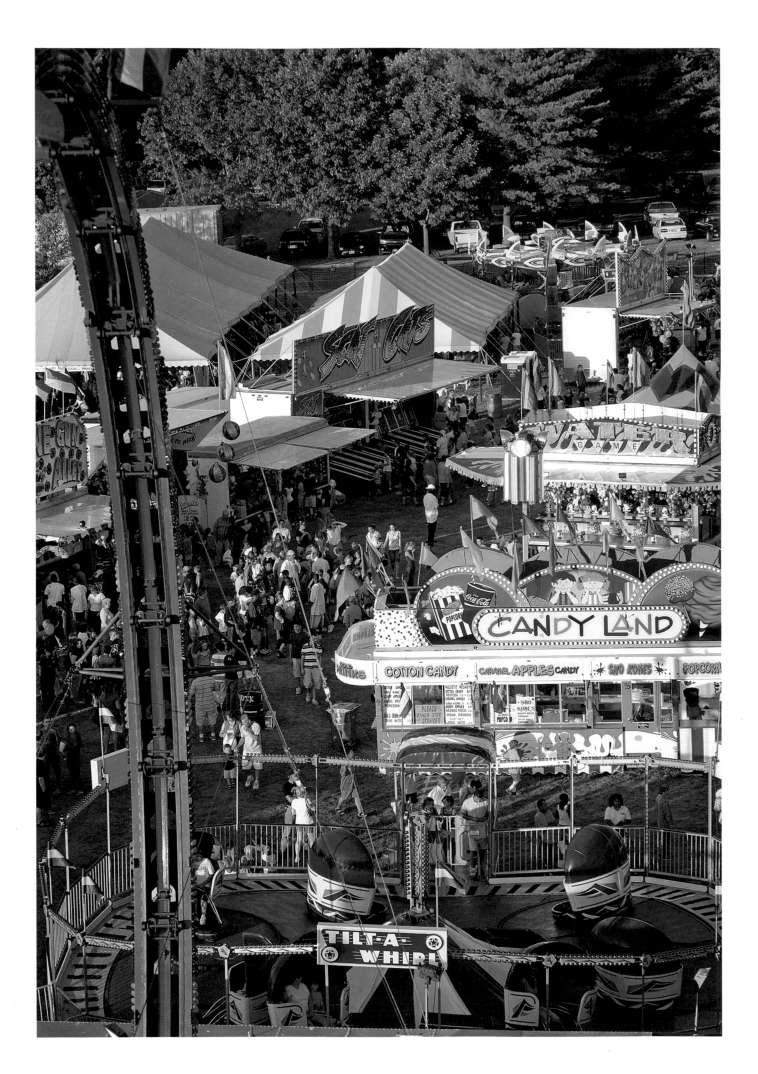

Visitors of the Burlington County Fair enjoy the sights, sounds, and excitement of the amusement rides. For over sixty years, the fair has entertained families and showcased the state's rich agricultural heritage.

The audience cheers as youngsters devour blueberry pies at the annual Burlington County Fair pie-eating contest.

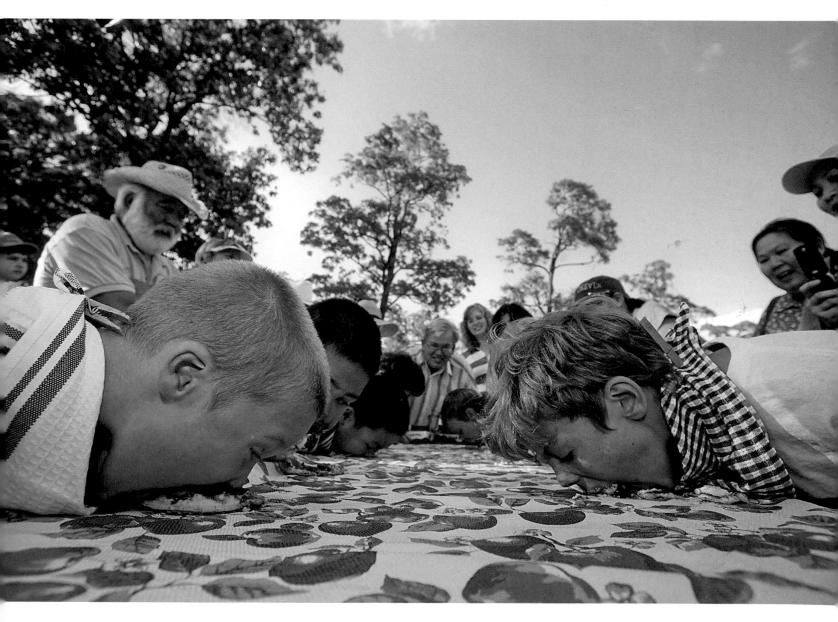

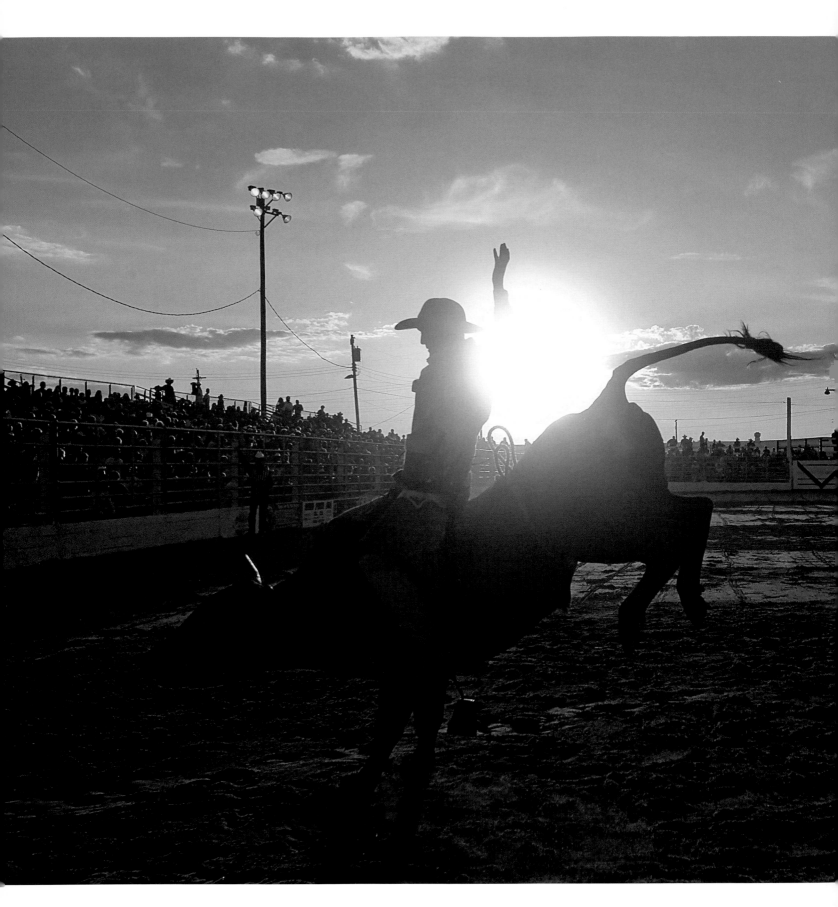

A cowboy tests his skill and courage at the weekly Brahma
bull-riding competition at the Cowtown Rodeo in Salem
County. As a stop on the Professional Rodeo Cowboys
Association–sanctioned rodeo circuit, Cowtown attracts
spectators from all across the state.

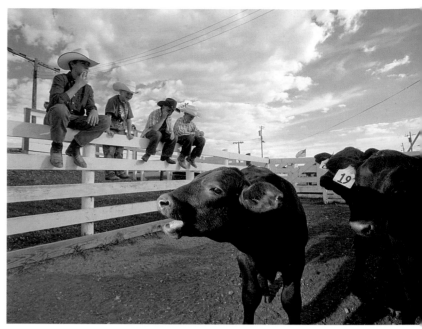

The next generation of steer wrestlers wait for the Brahma bull-riding event to begin at the Cowtown Rodeo.

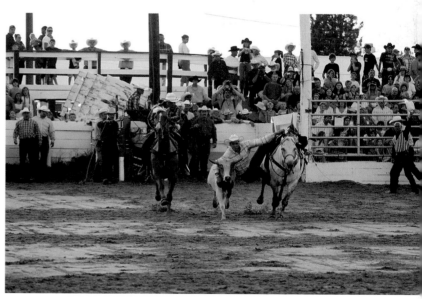

With nerves of steel, a cowboy demonstrates his skills.

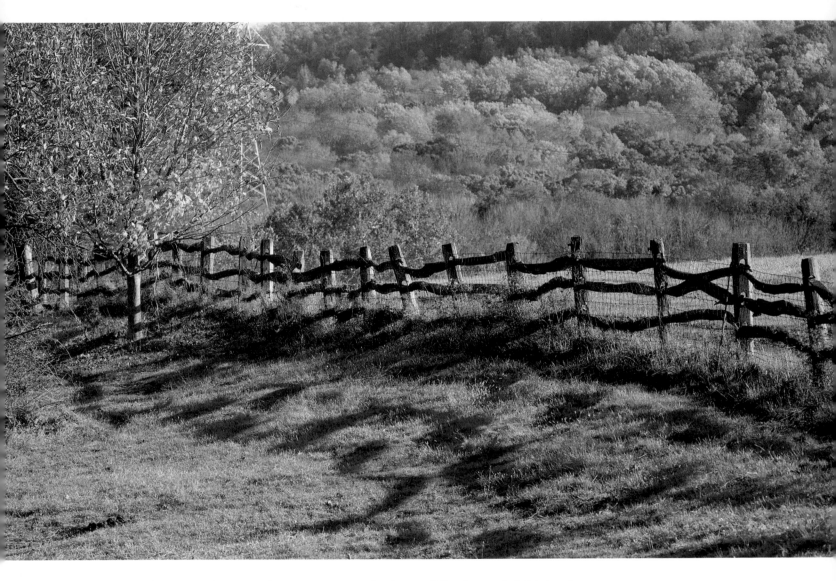

A preserved split-rail fence stands in testament to the hearty folk who settled this land.

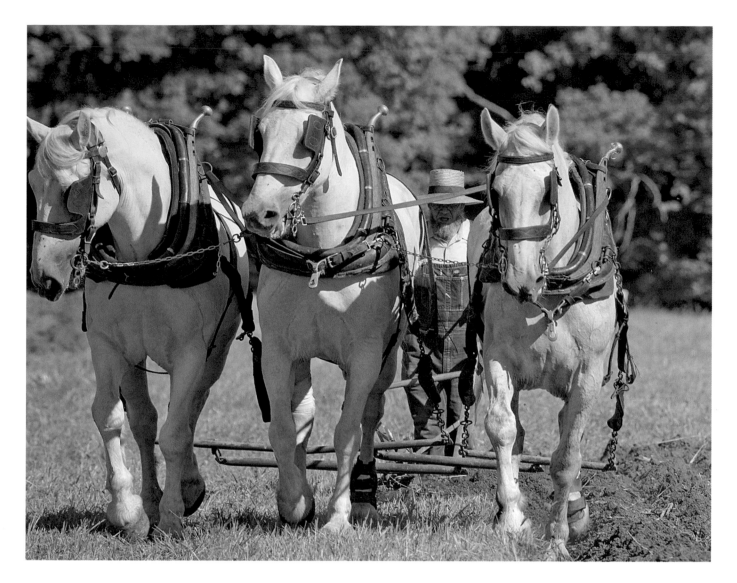

ABOVE

Agricultural enthusiasts travel back in time to the 1800s at the Howell Living History Farm to participate in the work and fun of New Jersey's only horse-drawn plowing match.

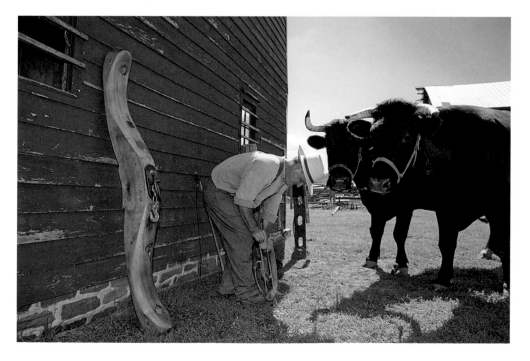

LEFT

A farmer prepares the plowing yoke to take his team of oxen to the fields. Visitors at the Howell Living History Farm in Mercer County can see firsthand the agricultural methods used in nineteenth-century farming.

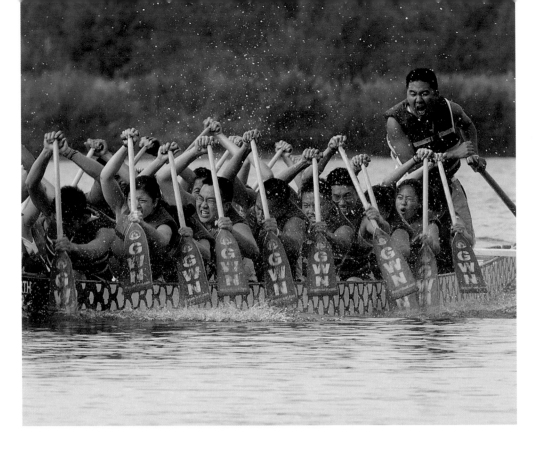

RIGHT

Professional rowing teams dig hard through the water at the annual Dragon Boat Races at Mercer County Park.

RIGHT

The dragon boats used at the races feature the head and tail of a dragon, a mythological creature regarded by the Chinese as having dominion over the waters and exercising control over rainfall.

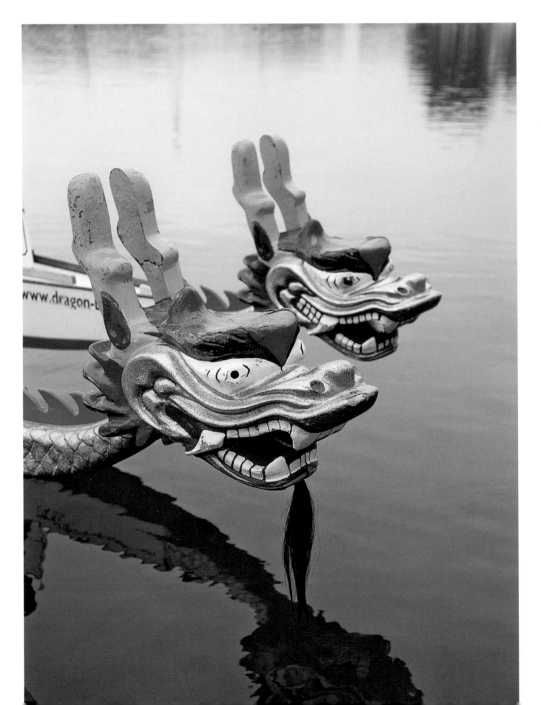

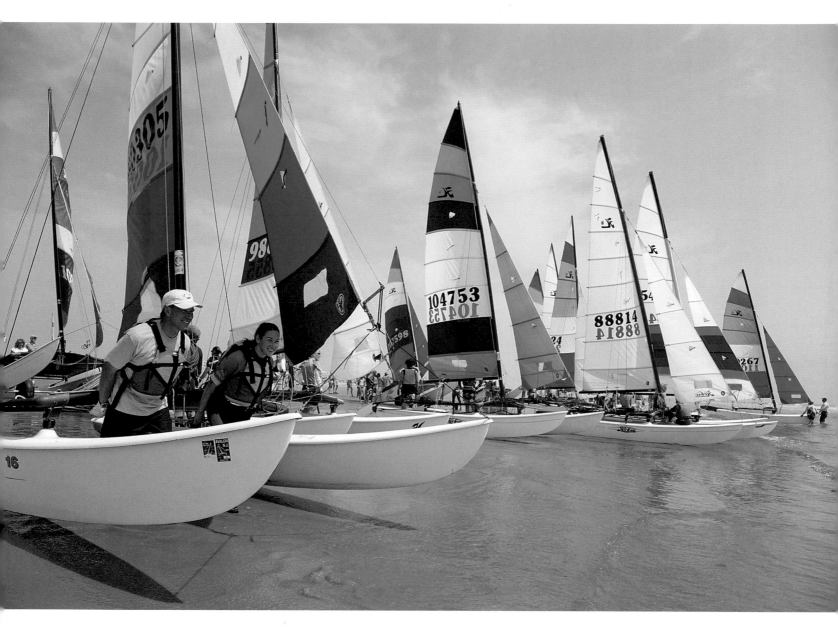

Every year Wildwood hosts the Classic Cup Hobie Cat Races. Hundreds of catamaran teams hit the ocean to test their skills with the wind and waves.

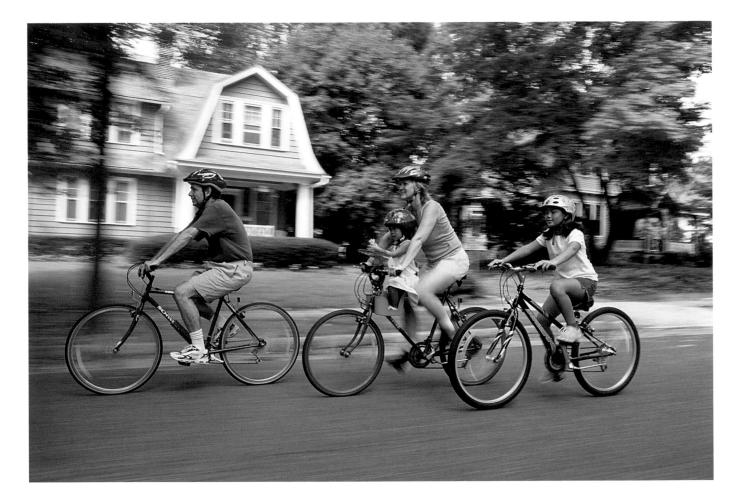

A New Jersey family bikes along the quiet residential streets of Moorestown.

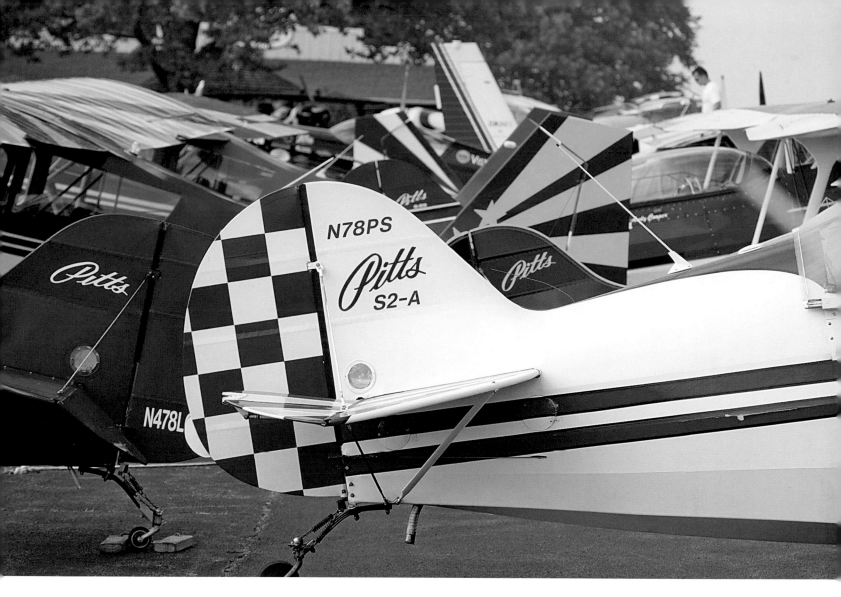

Aircraft congregate from across the country to participate in the annual Flying W Airport aerobatic competitions.

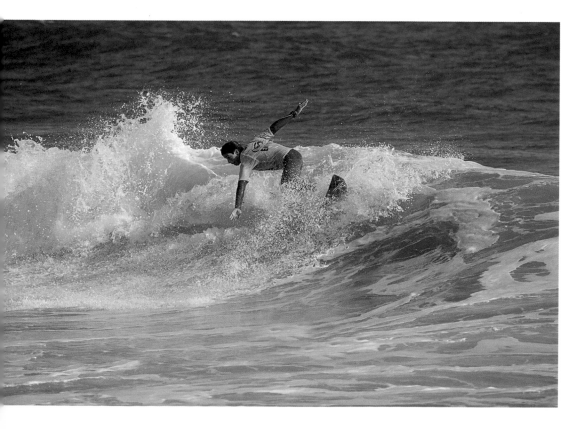

LEFT
Balancing and weaving on an incoming wave at Long Beach Island, a shortboard surfer carves his way toward shore.

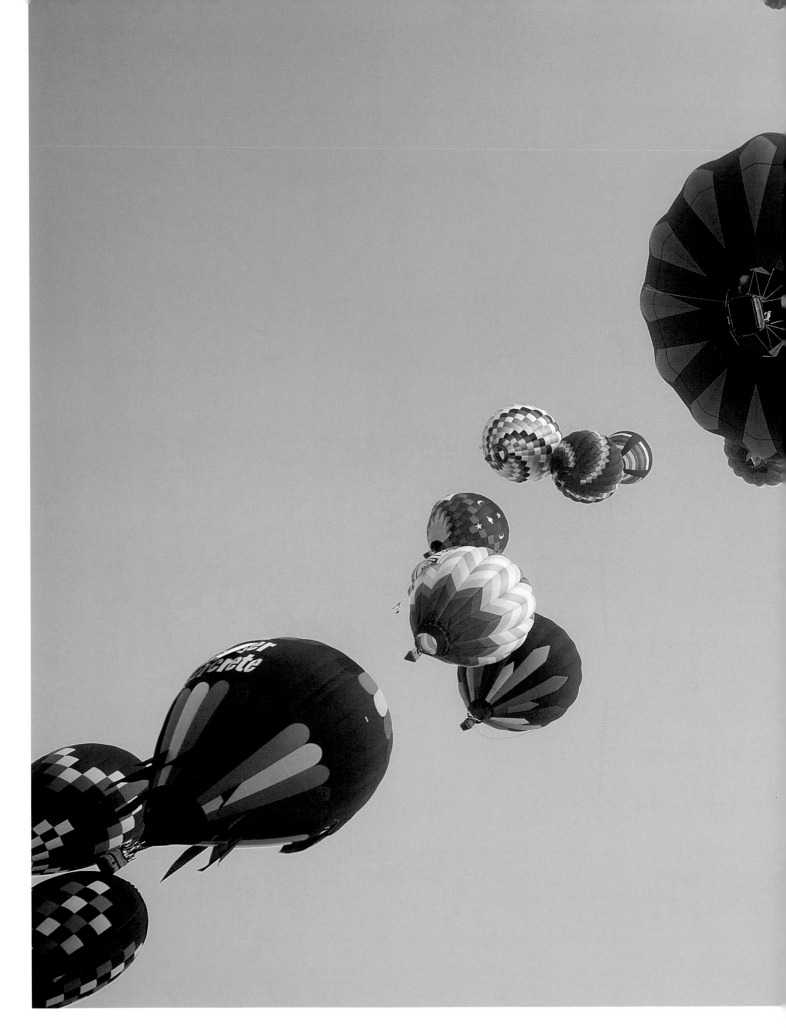

Lighter than air, more than 125 hot air balloons begin their flight in the annual summertime New Jersey Festival of Ballooning in Readington.

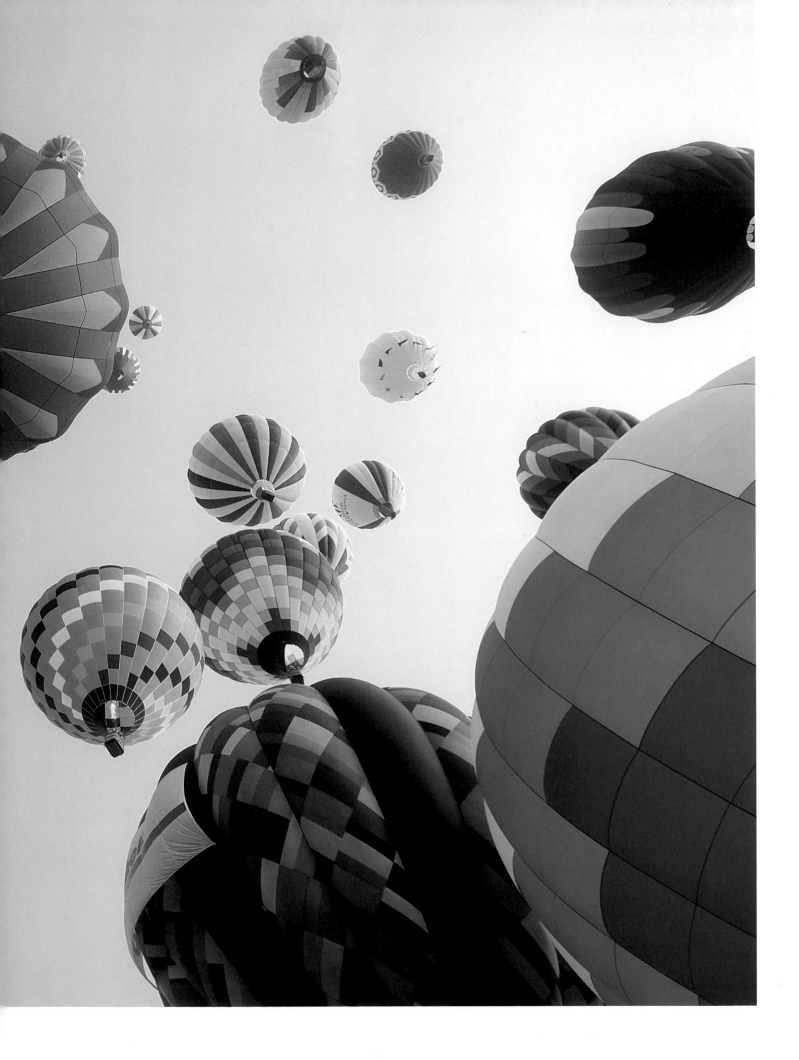

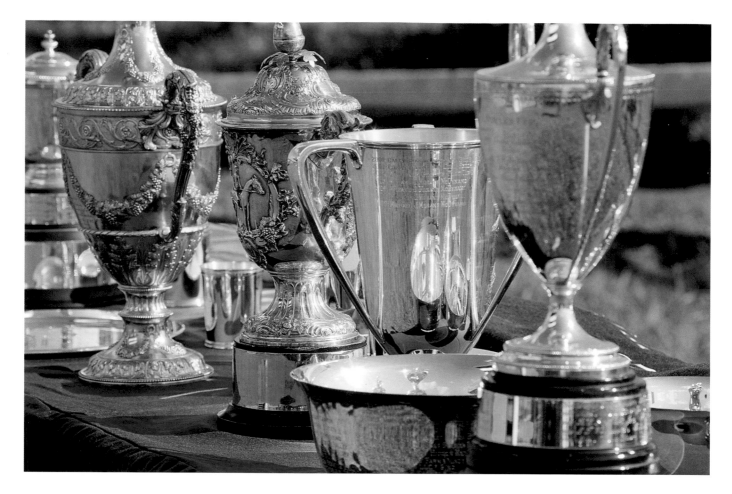

All the trophies for the six stakes races at the Breeders' Cup Grand National Steeplechase in Far Hills are prominently displayed before the race.

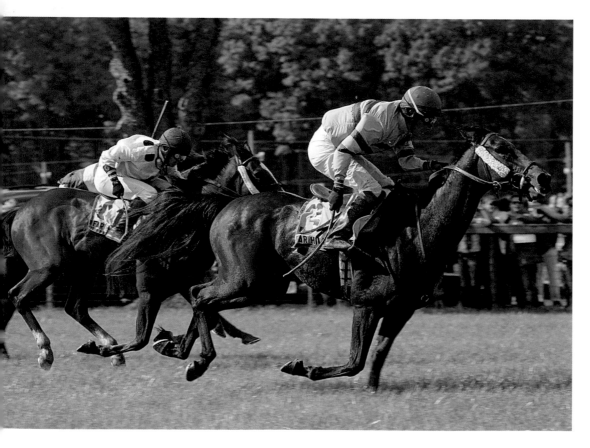

The Far Hills Race Meeting at Moorland Farms is the most prestigious, most well-attended, and richest steeplechase horserace event in the United States.

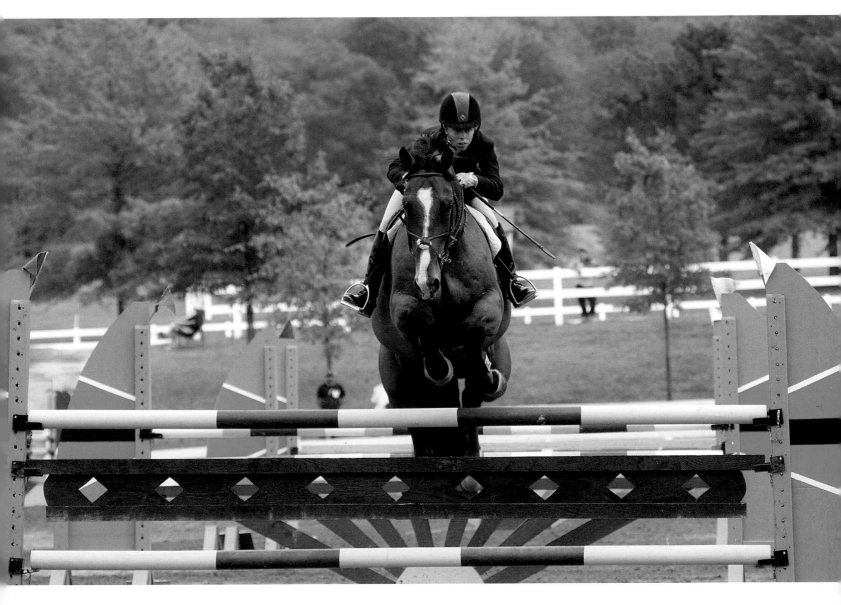

Equestrian riders compete in the annual Horse Jumping Grand Prix contest at Horse Park of New Jersey.

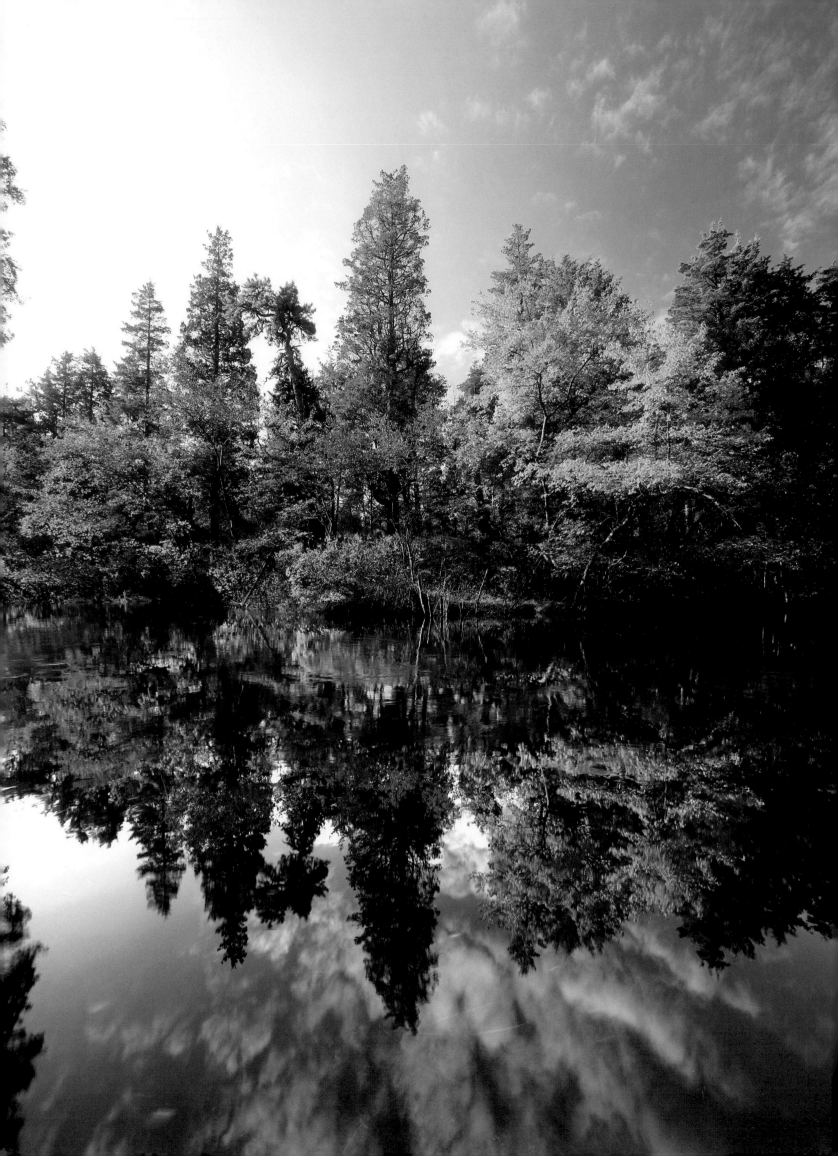

OPPOSITE
Glorious fall reflections in the Batsto River offer a
kaleidoscope for the senses.

BELOW
Autumn maple leaves are a colorful example of the nutrients required for the success of the next spring's blooms.

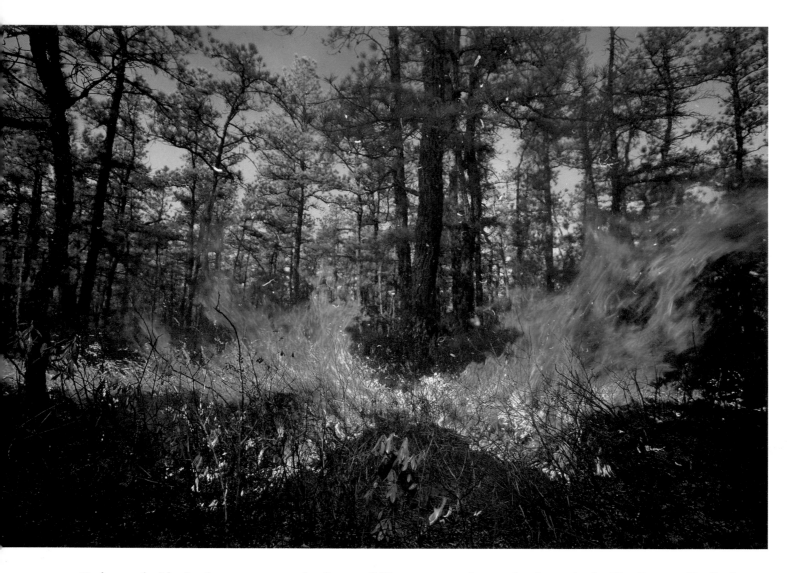

Each year during the dry summer months, forest wildfires consume thousands of acres in the Pine Barrens. Yet fire is actually beneficial to the forest. An adaptation of the pinecones requires the heat of the flames to melt the resins holding the cones together. This allows them to burst and send out seeds to start the regeneration of the forests, promoting the resiliency of the Pine Barrens forest ecology.

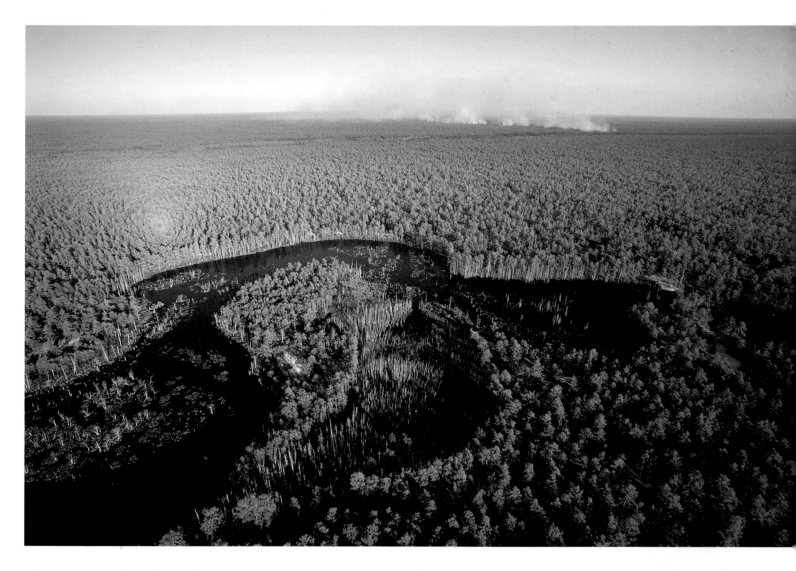

The Batsto River flows through over one million acres of pitch-pine forest. The expansive Pine Barrens make up 22 percent of New Jersey's land area.

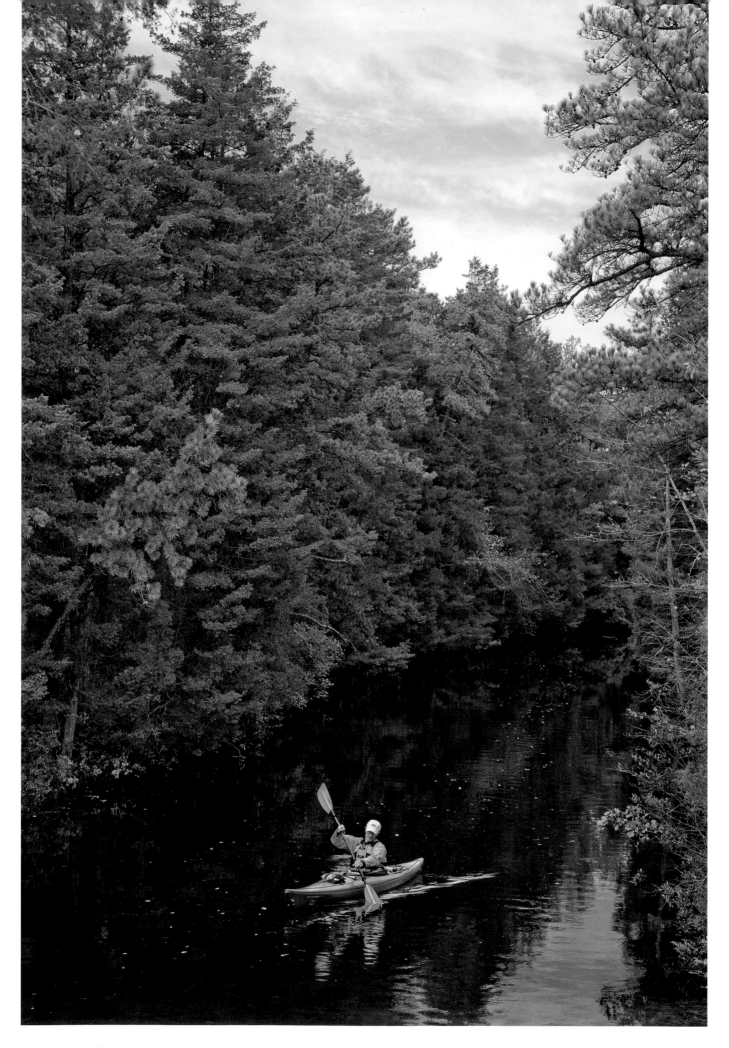

A kayaker enjoys the solitude of the tranquil Oswego River in Wharton State Forest.

The dramatic rays of the sun outline the inspirational beauty of a sunlit cloud.

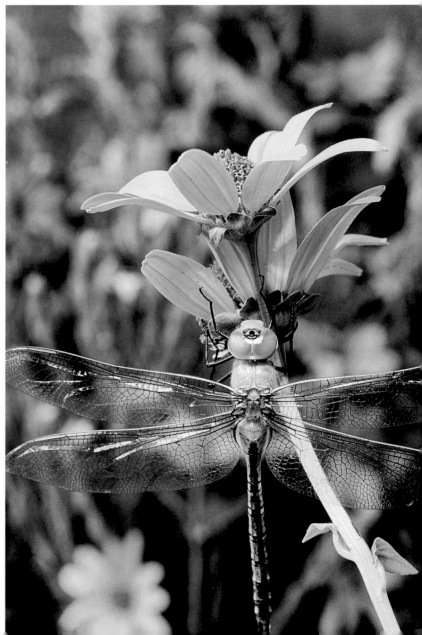

RIGHT

A common green Darner dragonfly warms itself in the summer sun.

RIGHT
Doing its best impression of a curly fern, this white-tailed fawn hides and waits for its mother to return.

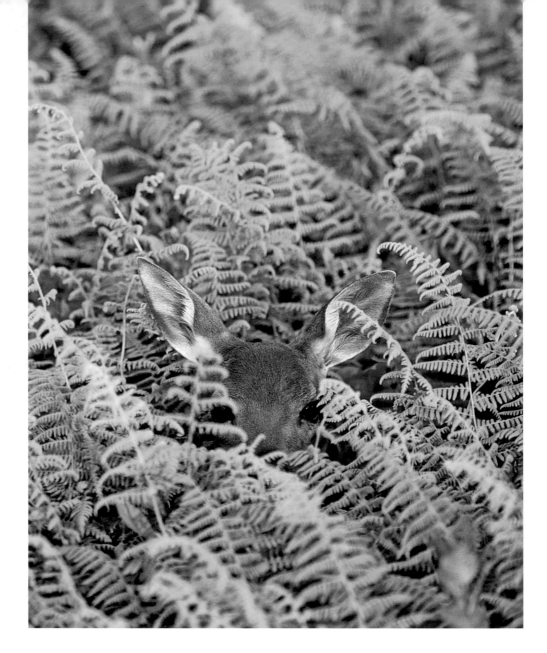

RIGHT
An endangered eastern box turtle peers cautiously with each advancing step.

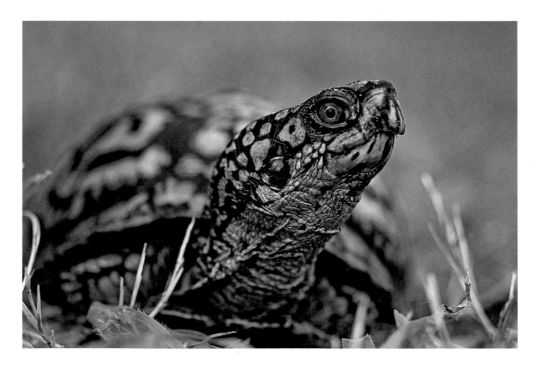

OPPOSITE
Rancocas Creek weaves its way through the autumn splendor of historic Smithville Park in Burlington County.

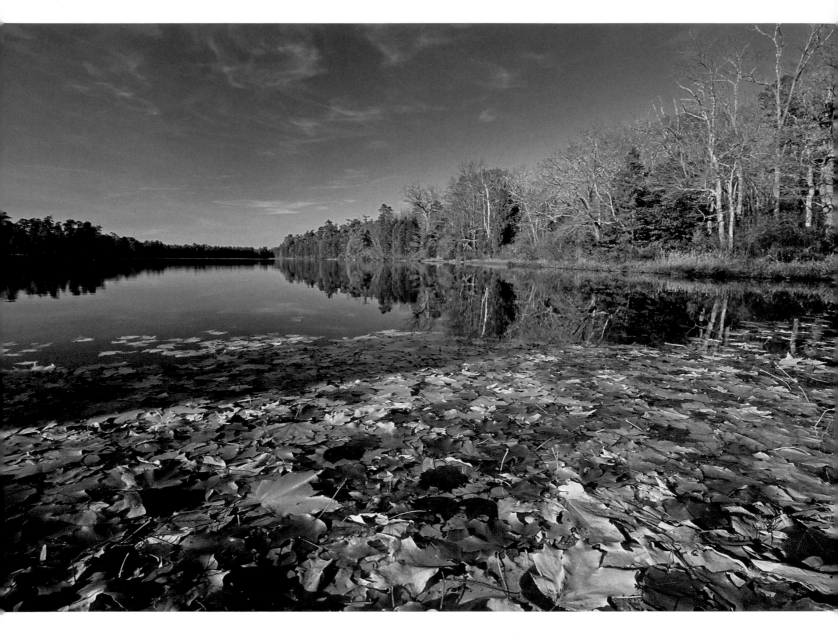

In Wharton State Forest, the gentle current of the Batsto River reunites fallen autumn leaves into a chorus of color.

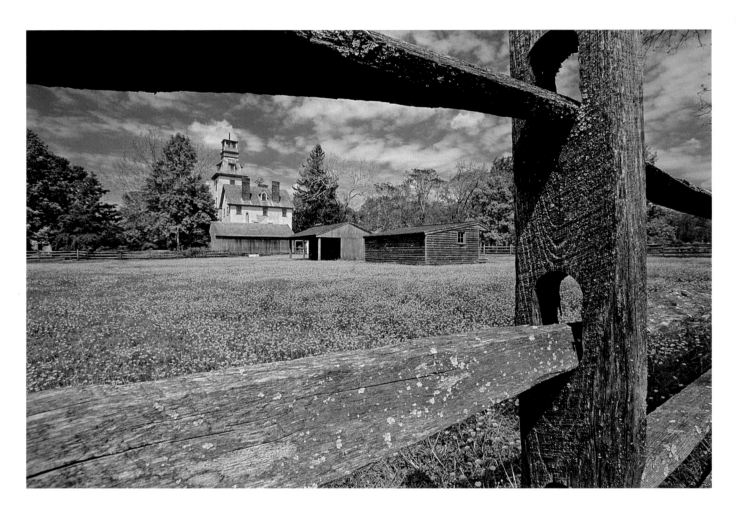

Nestled beyond a quilted meadow of blooming flowers, Batsto Mansion in Hammonton's Batsto Village was the residence of past generations of ironmasters.

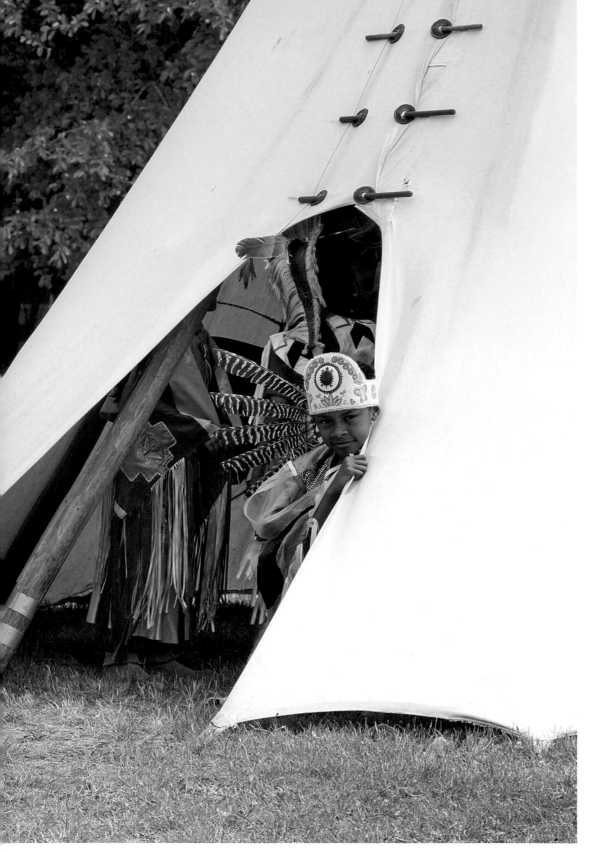

Playful Nanticoke Lenni-Lenape children enjoy a game of hide-and-seek. The Nanticoke Indians host an annual powwow, which is open to the public. The festival presents an opportunity for the Indians and other neighboring tribes to display, practice, and share the skills acquired through their rich heritage.

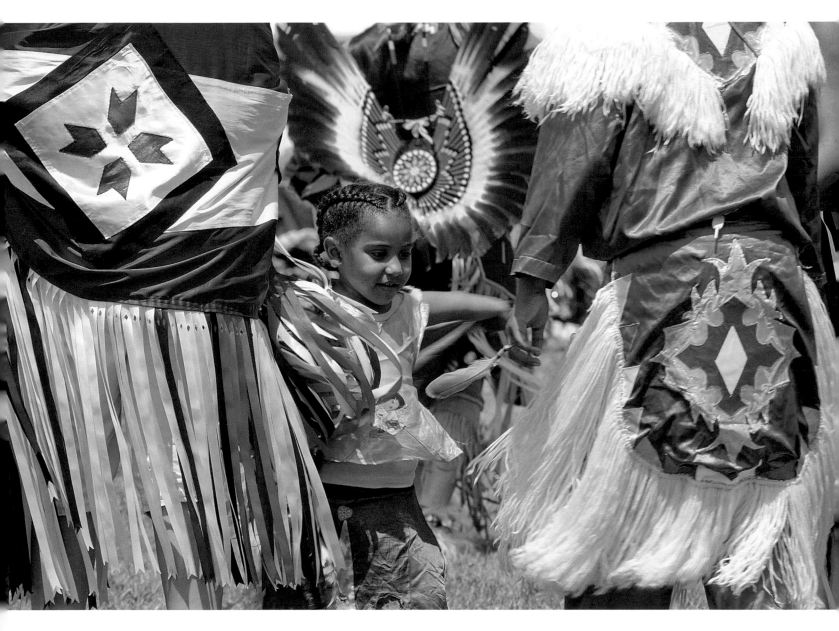

Dancing in full regalia, the Nanticoke Lenni-Lenape Indians celebrate their heritage. The Lenape ancestors of this modern tribe are direct descendents of the Native Americans who inhabited New Jersey as long as twelve thousand years ago.

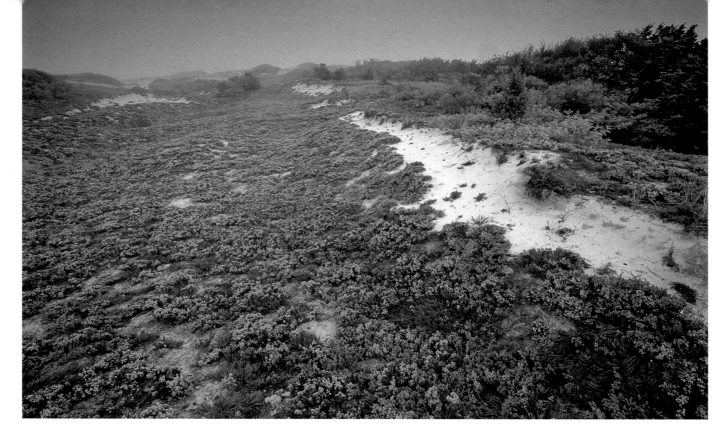

A spring carpet of blooming beach heather covers the coastal sand dunes at Island Beach State Park.

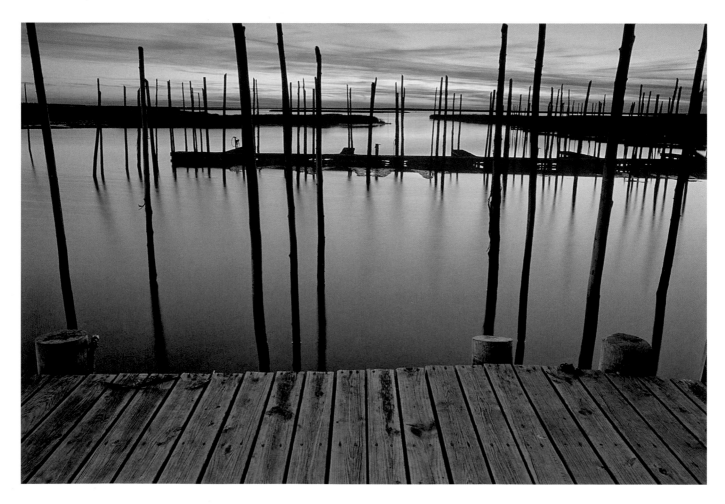

With only the mooring poles left to witness the end of another boating season, the last rays of the evening sky illuminate a deserted marina at Great Bay Wildlife Management Area.

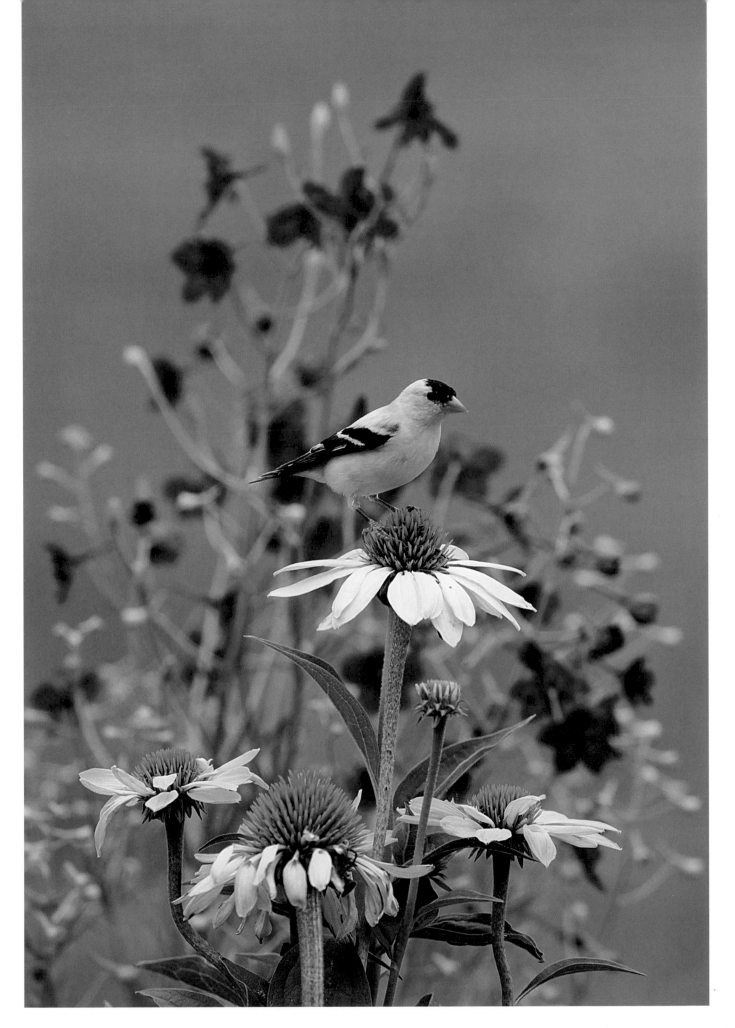

Adopted as New Jersey's state bird in 1935, the eastern goldfinch is a welcome year-round resident in many backyard gardens. The male goldfinch wears bright yellow feathers and a snappy black cap.

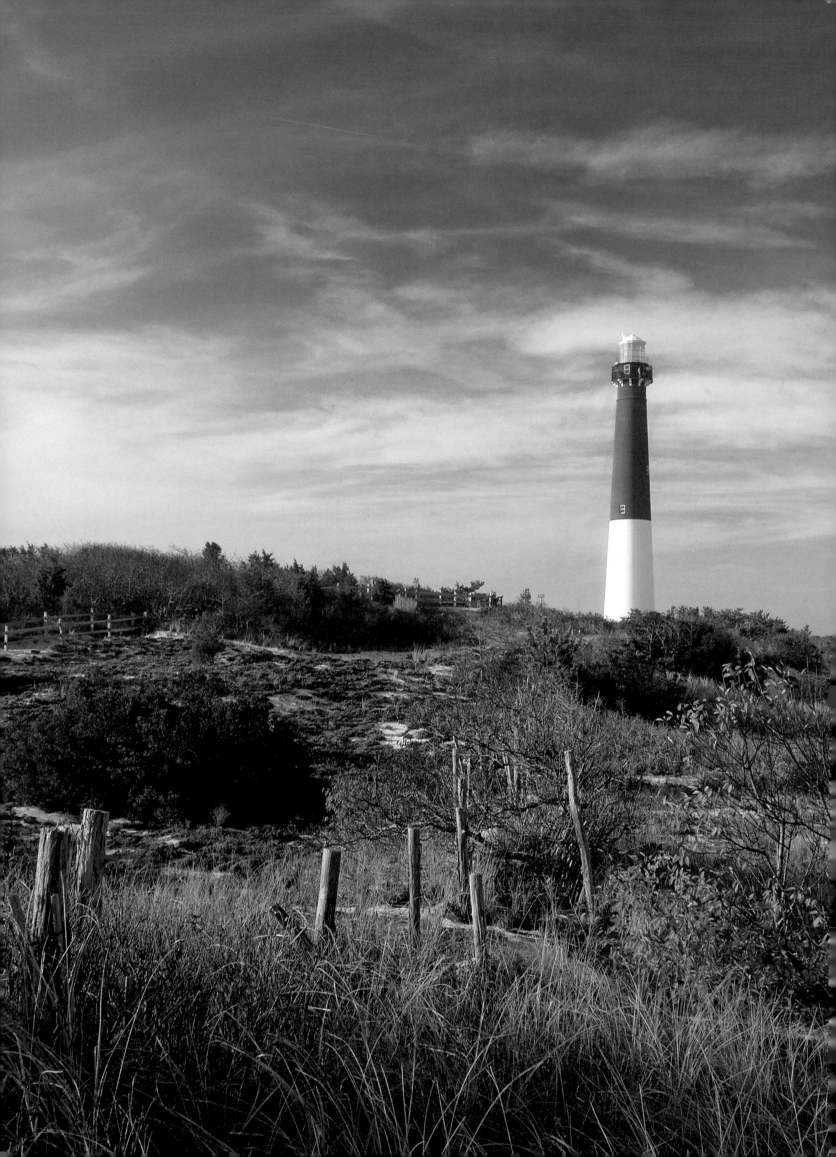

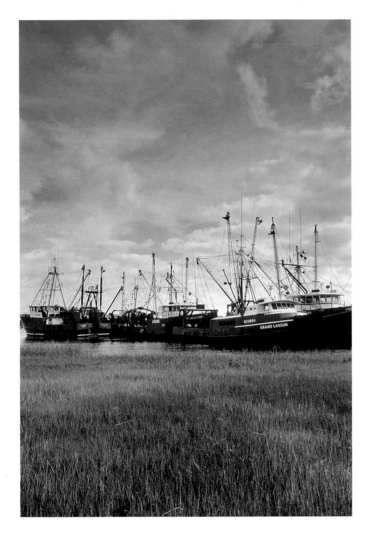

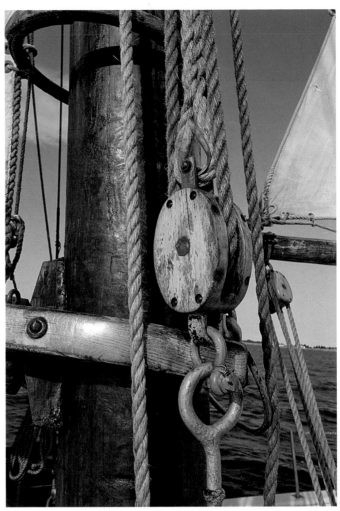

Commercial fishing trawlers rest in the Barnegat Marina, located at Barnegat Lighthouse.

Fully rigged, the lines and turnbuckles on the historic tall ship, *A. J. Meerwald,* stand taut and ready.

Affectionately known as "Old Barney," the Barnegat Lighthouse has been standing vigil on the north tip of Long Beach Island since 1859. No longer used to guide mariners, the beacon continues to attract thousands of visitors every summer who learn about its history and climb the 165-foot height to see panoramic views of the coastline.

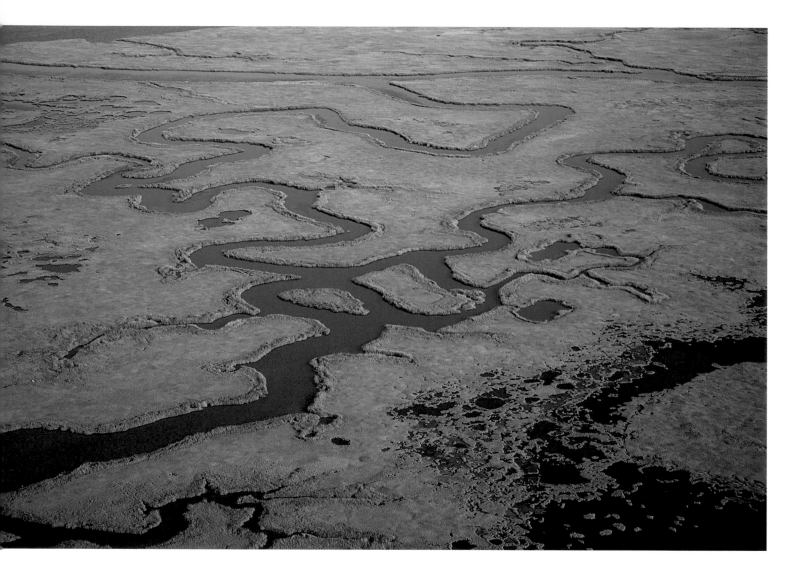

The endless tides and rich nutrients of the Absecon Bay constantly create new textures and serpentine channels within the coastal salt marshes.

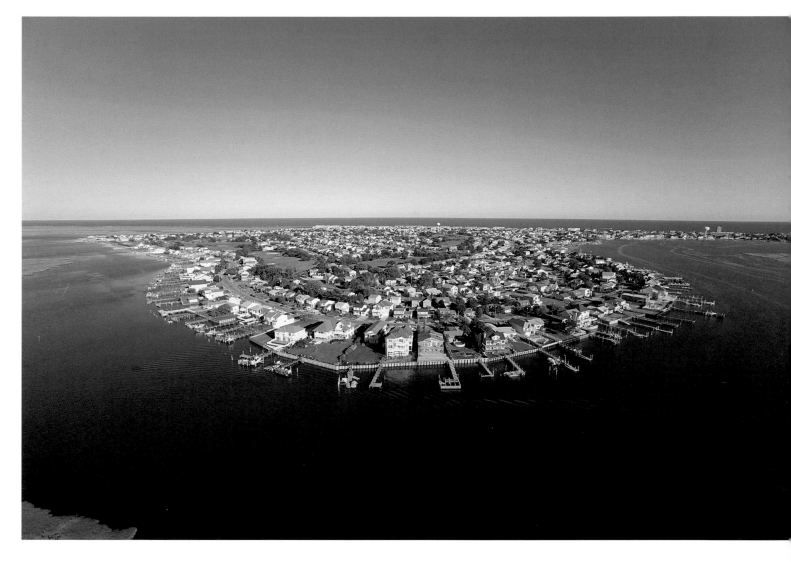

With the back bay on one side and the Atlantic Ocean on the other, the Brigantine Island community is a popular summertime getaway and year-round home for shore goers.

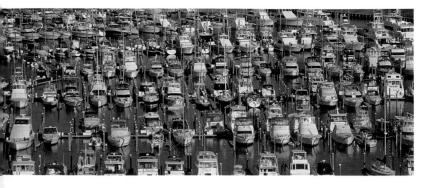

ABOVE

A marina at Egg Harbor illustrates the popularity of recreational boating along New Jersey's coastal waters.

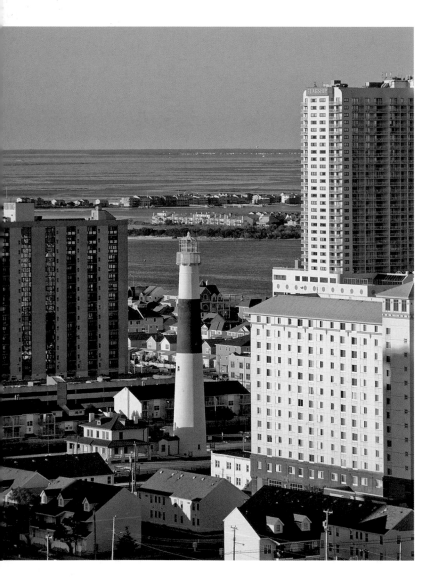

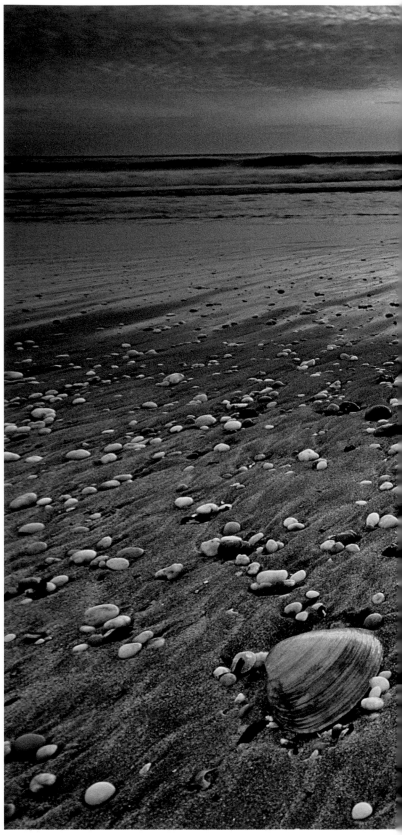

ABOVE

At 171 feet, the Absecon Lighthouse is the tallest lighthouse in New Jersey and the third-tallest lighthouse in the United States. The lighthouse first lit Atlantic City's coastline in 1857, but by the dawn of the twentieth century, nearby buildings and hotels obscured its panoramic views.

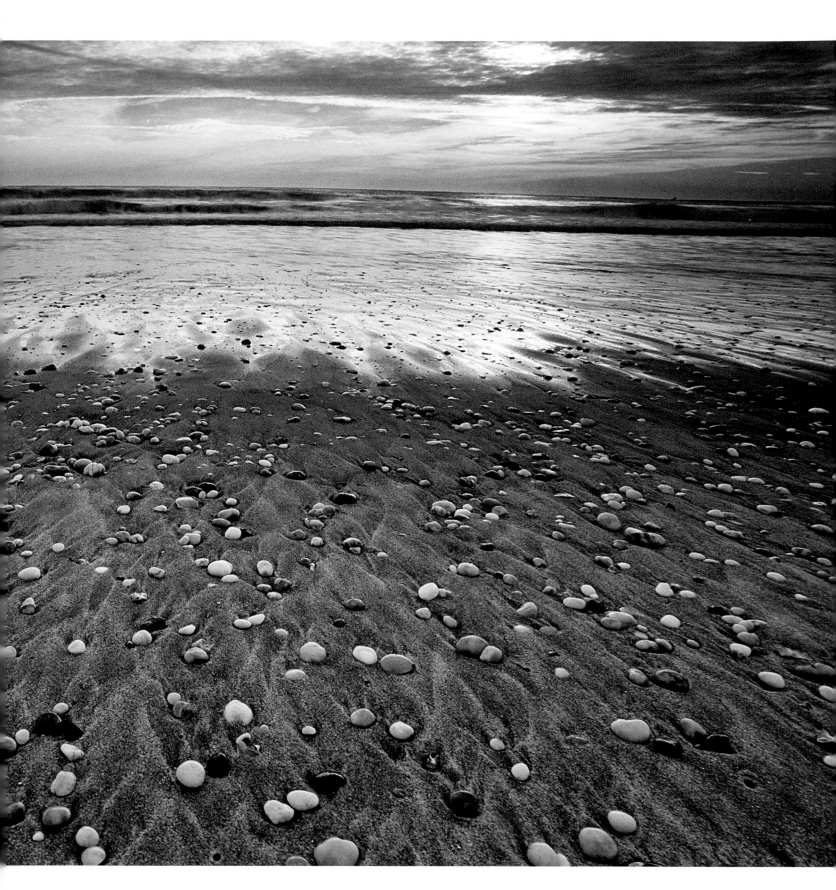

During low tide, the fine-grain beaches at Stone Harbor
reveal countless treasures for beachcombers.

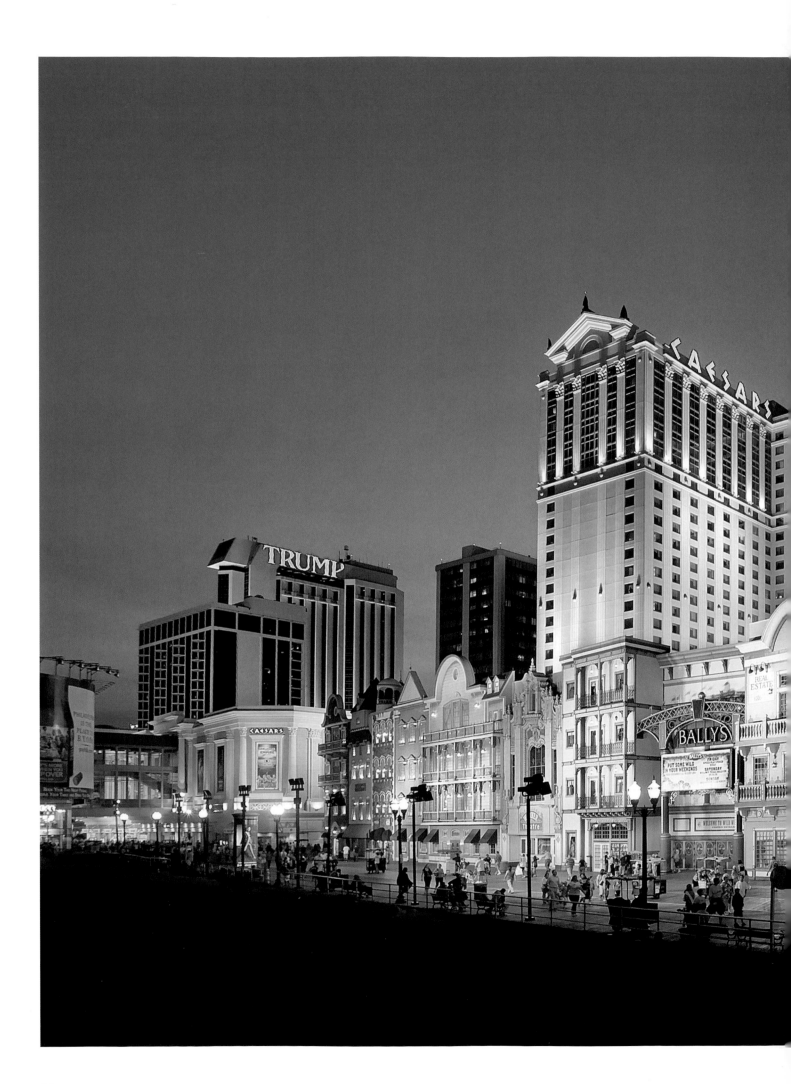

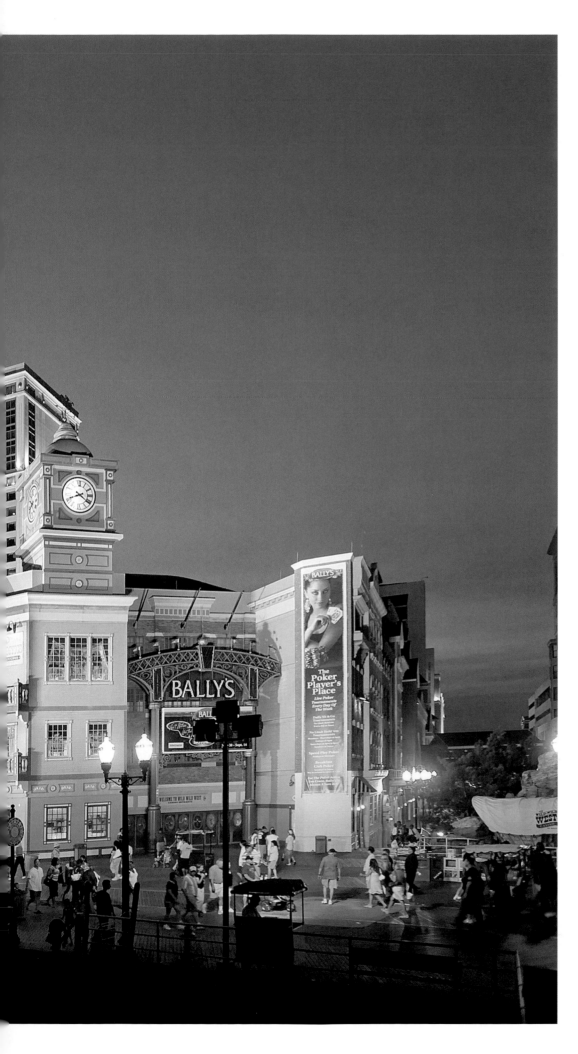

Summertime tourists enjoy the time-honored tradition of walking or bicycling on Atlantic City's famous boardwalk. With the casinos as a backdrop, the boardwalk attracts more than thirty million people each year.

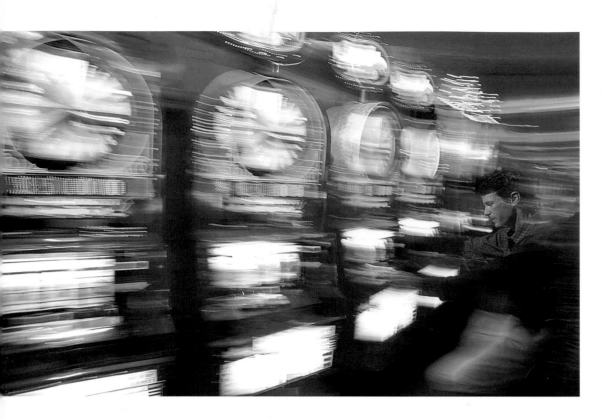

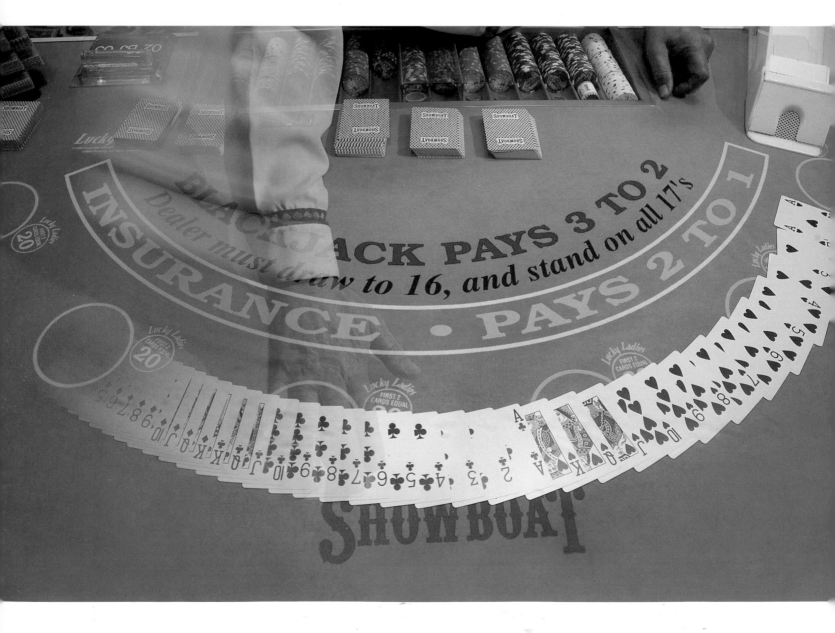

The Trump Taj Mahal Casino Resort is one of twelve mammoth casino hotels in Atlantic City. The resort town offers vacationers a variety of entertainment and lively nightlife options, as well as the lure of the casinos.

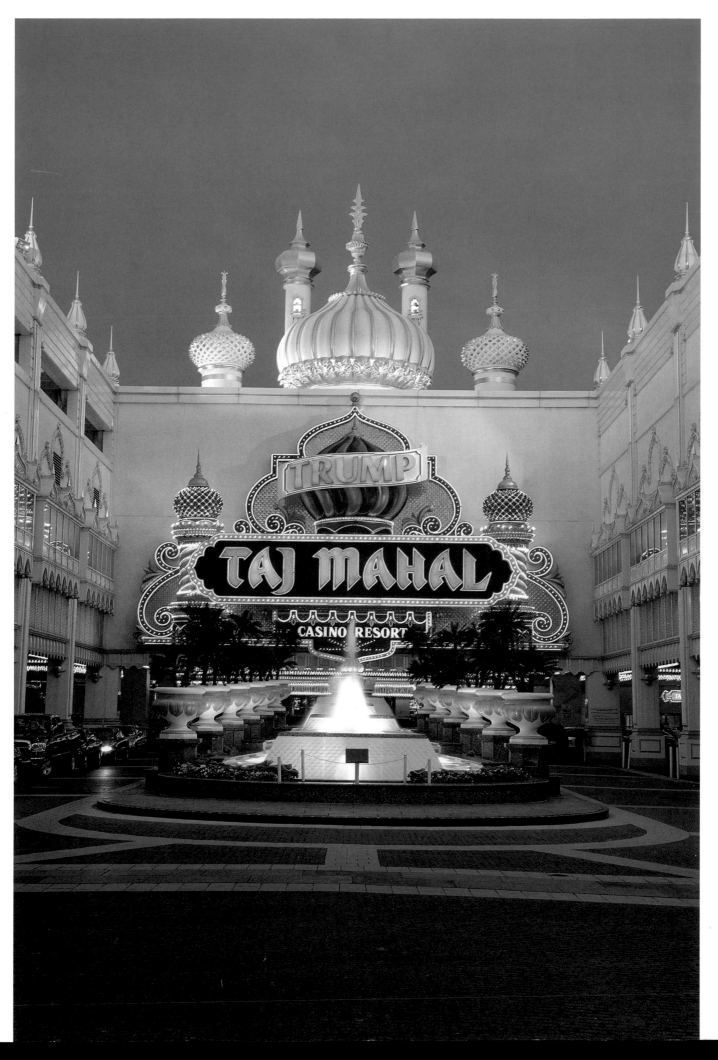

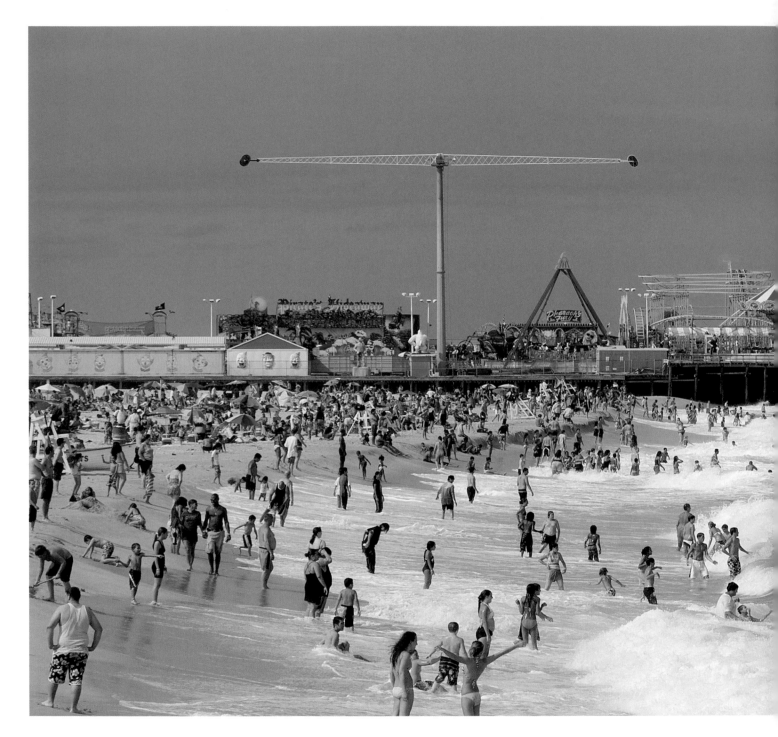

The Funtown Amusement Pier and the warm ocean waves are huge draws for summer beachgoers in Seaside Heights.

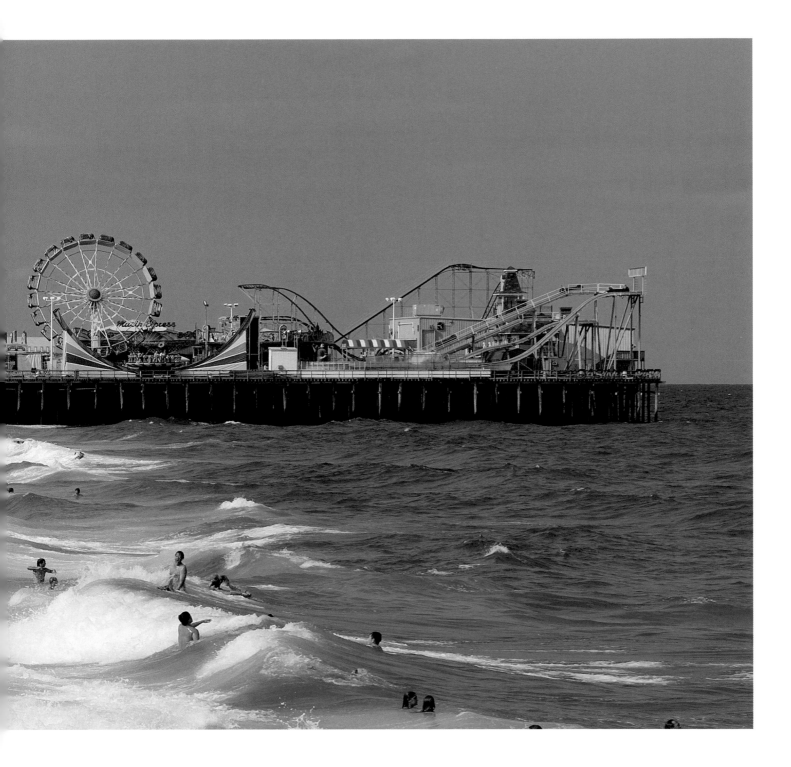

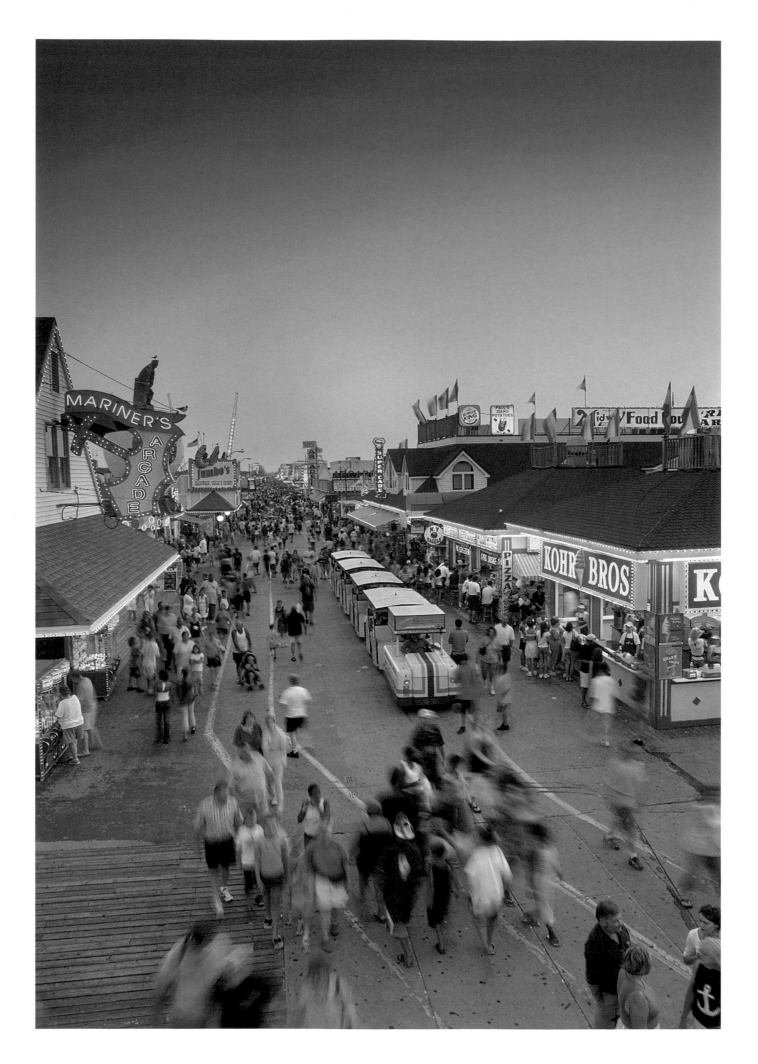

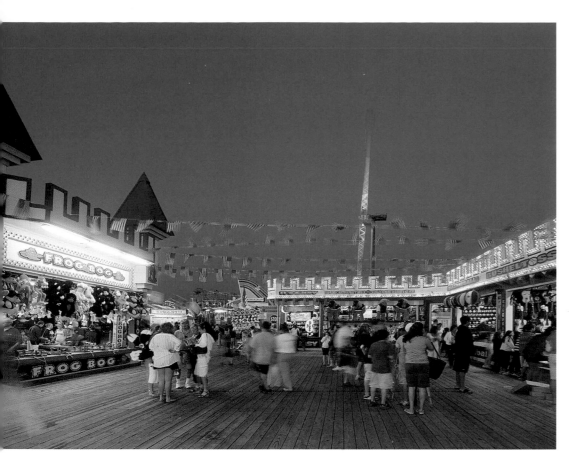

Games of chance for prizes ranging from stuffed animals to televisions lure an evening crowd to the boardwalk in Seaside Heights.

RIGHT

Faster spinning makes for more enjoyment on the amusement rides in Ocean City.

OPPOSITE

Where would you be if you heard, "Watch the tram car, please"? At the Wildwood Boardwalk, of course. Electric tram cars have transported summer tourists down the three-mile-long wooden boardwalk for more than fifty years.

You have to get up early in the morning if you're going to catch a ghost crab. Named for being able to disappear quickly from sight, these creatures are able to run at speeds up to ten miles per hour and only come out of their beach burrows at sunrise.

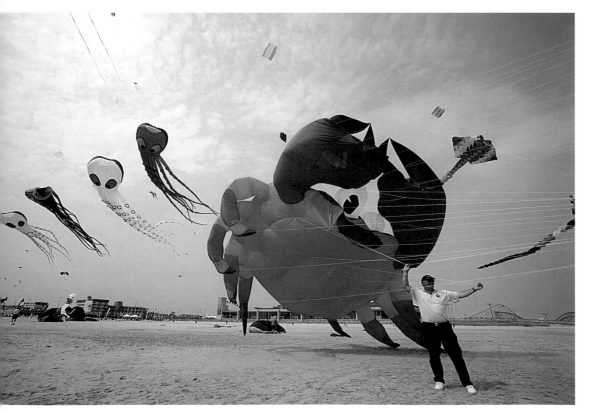

LEFT

Kite flyers from across the globe gather to show off their giant kites at the International Kite Festival on the beaches of Wildwood.

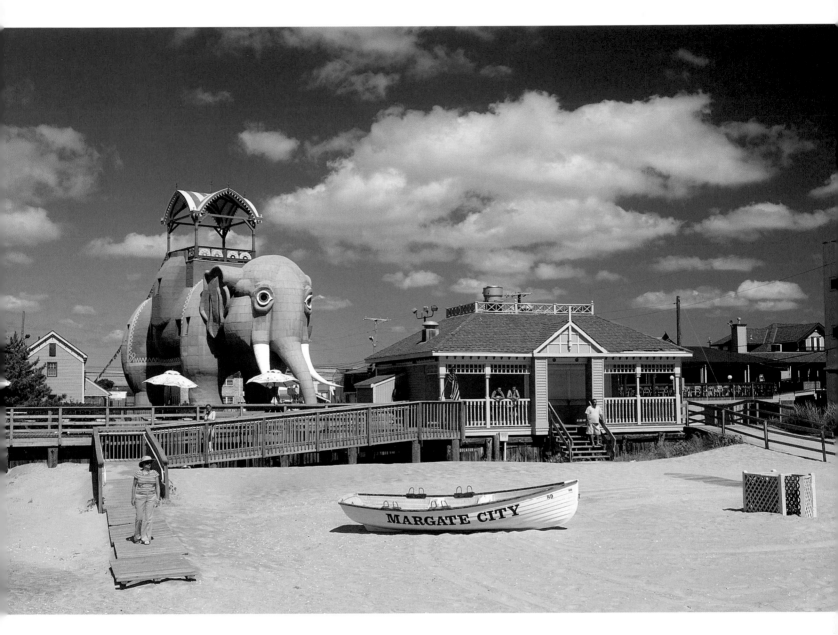

A national historic site as well as a unique example of the eccentric architecture of the late Victorian age, Lucy the Elephant is a must-see tourist attraction in the Atlantic City area. Located in the neighboring town of Margate, the elephant-shaped building required over one million individual pieces of wood, ninety tons of steel, and a sheath of hammered tin when it was constructed in 1881.

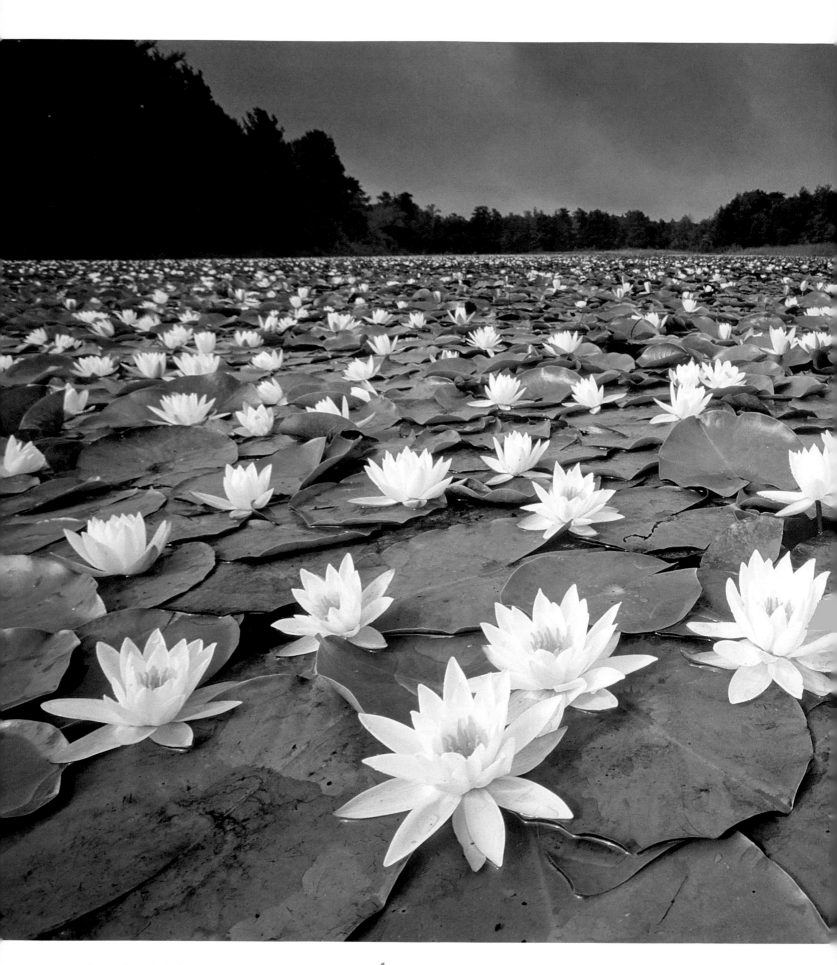

Like a whimsical dream, the fragrant blooms of the native American white water lily transform a pond near Dividing Creek in southern New Jersey.

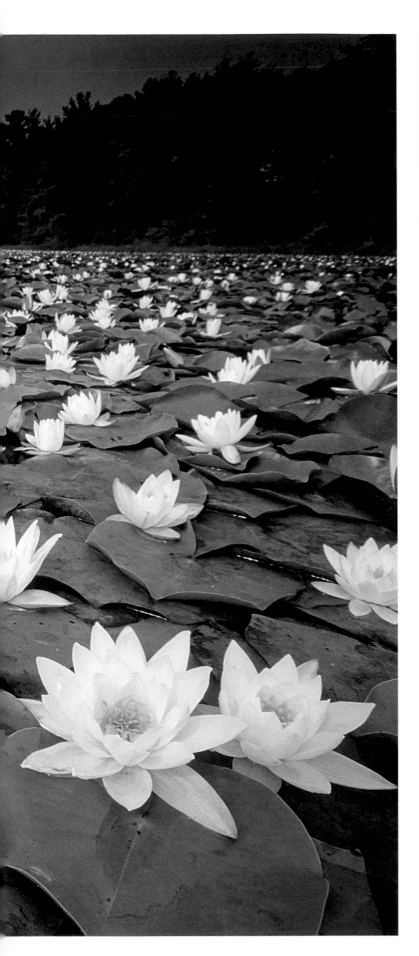

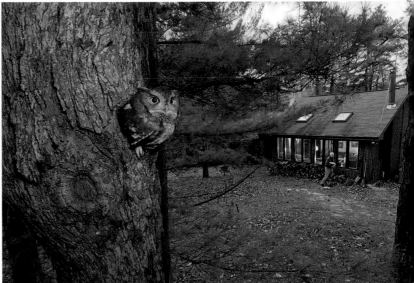

As nighttime approaches, an eastern screech owl emerges from its nest cavity. These pint-sized owls are welcome residents to the lucky folks that live in the Pine Barrens. Bidding wars on homes for sale that have an active owl nest on the property are common.

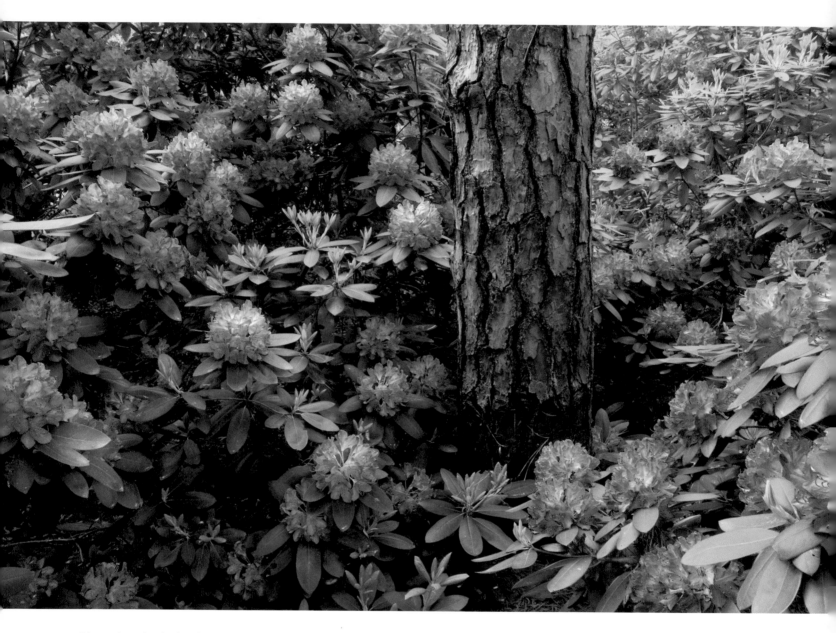

Blooming rhododendrons announce the arrival of summer in the Pine Barrens.

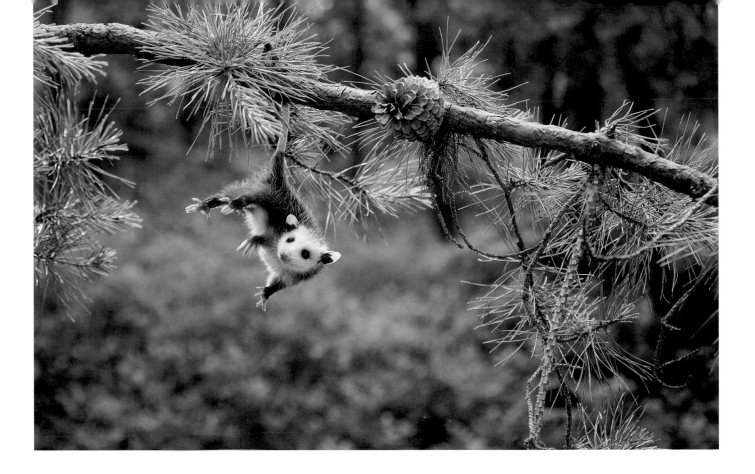

ABOVE

Opossums are common in the Pine Barrens and make their homes in the trees. While youngsters learn to climb and balance in the branches, they sometimes use their tails to catch themselves if they slip off.

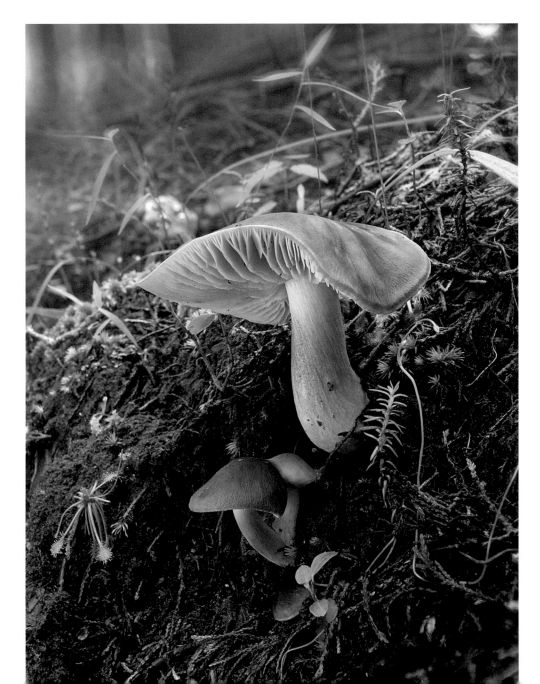

LEFT

Wild mushrooms grow profusely in the moist soils of the pineland forests.

OVERLEAF

Crepuscular rays bathe the seemingly endless pine trees in the Wharton State Forest.

109

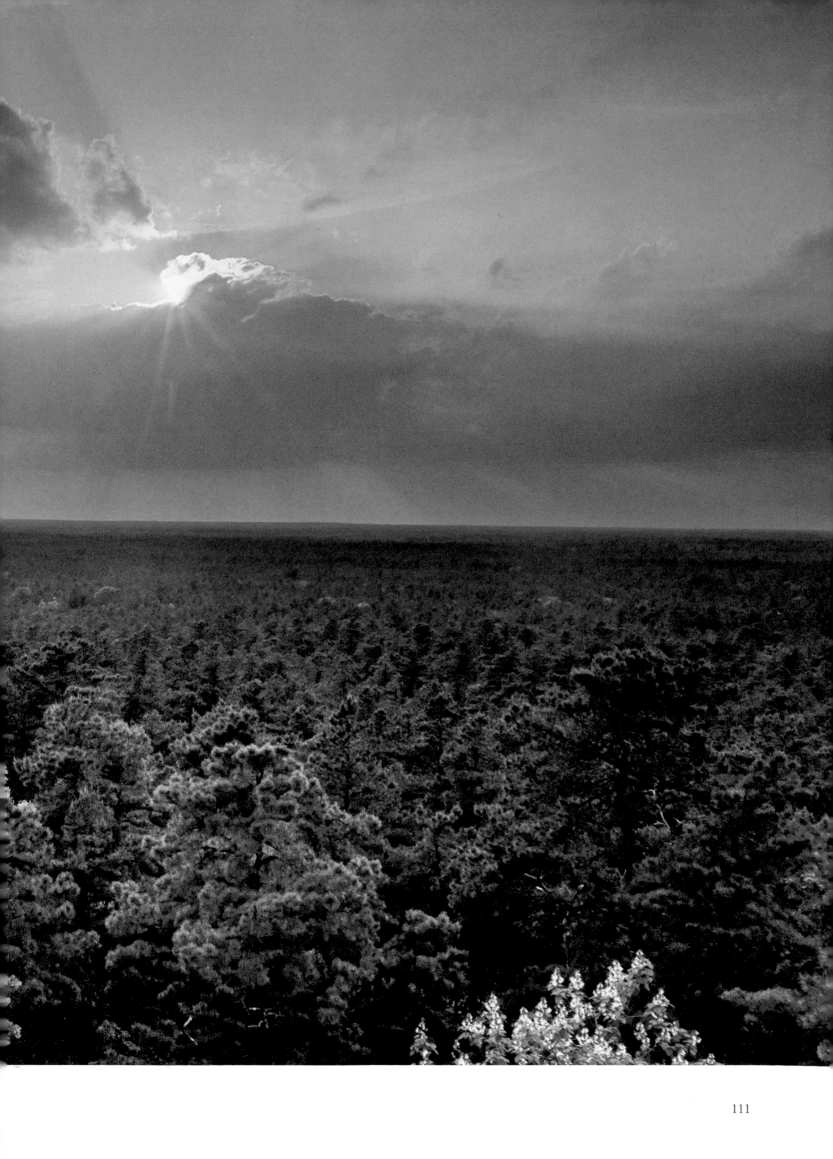

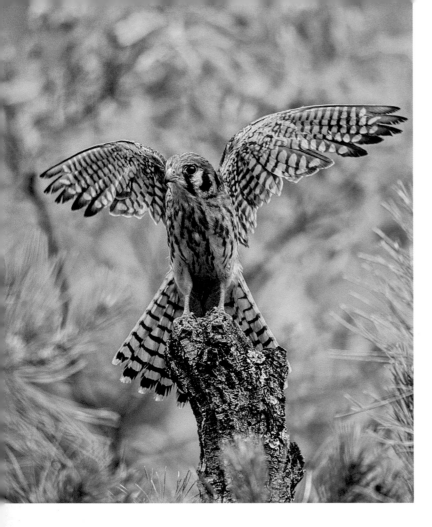

New Jersey's smallest and most colorful falcon, the American kestrel, is an elusive resident in the grasslands. This robin-sized raptor assists farmers in their pest management by subsisting on large insects and small rodents.

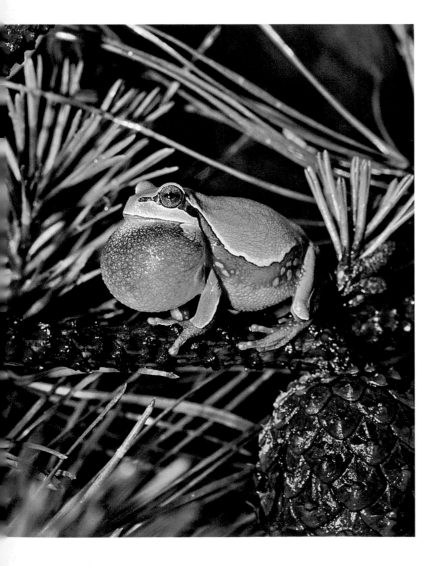

LEFT

The male Pine Barren tree frog vocalizes his nasal-sounding courtship "honks" on the most humid and hot nights in June. Found only in the deep, wet reaches of the Pine Barrens, and measuring the size of your thumb, this endangered species has become an iconic symbol of all the efforts to conserve and protect the Pinelands from development.

OPPOSITE

The fragile and endangered swamp pink still blooms in the untouched bogs of the Pine Barrens.

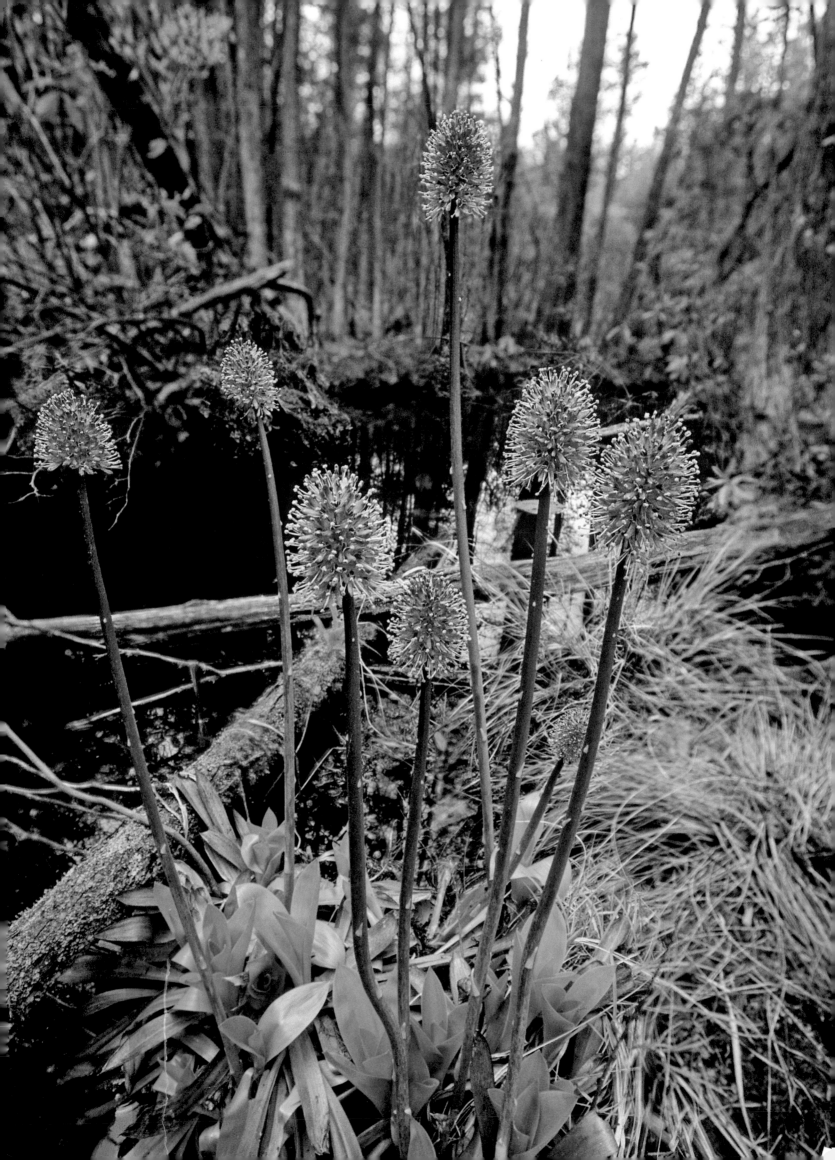

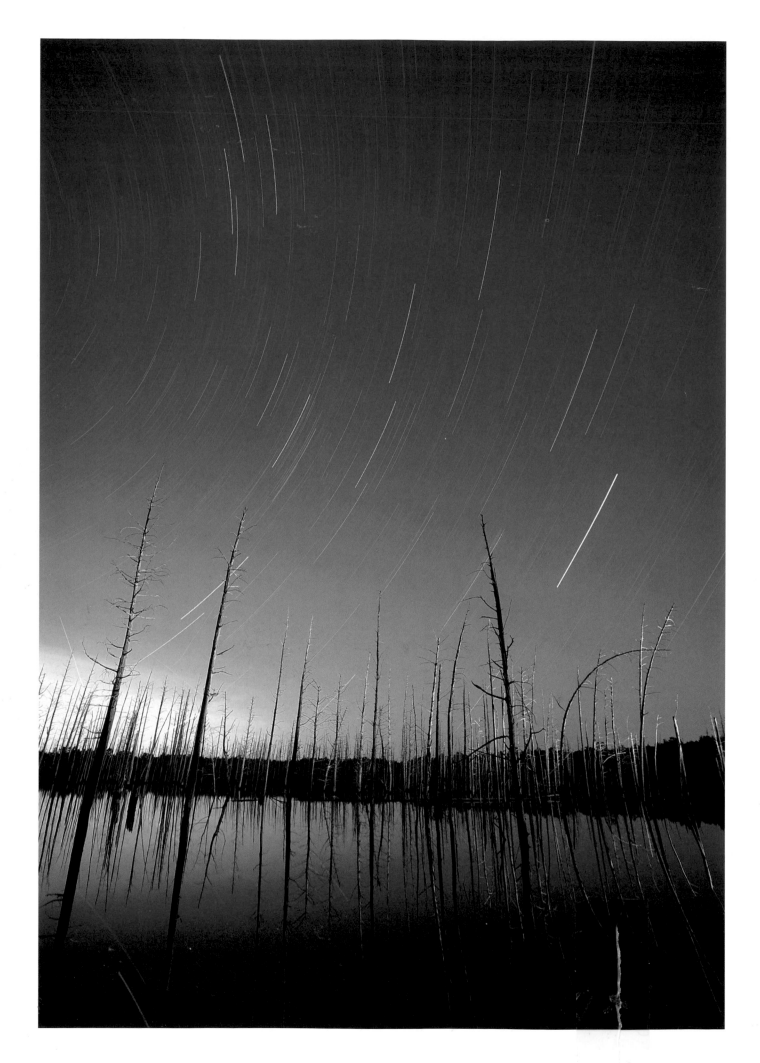

As our earth turns on its axis, the night sky spins over an
Atlantic white cedar bog deep in the heart of the
Pine Barrens.

BELOW

Blazing-star wildflowers stand at attention in a Hunterdon County meadow.

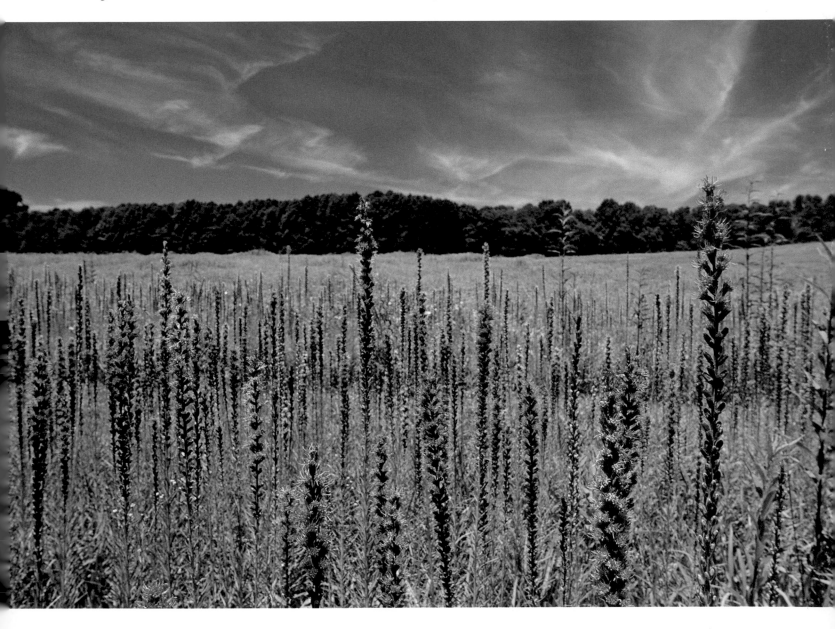

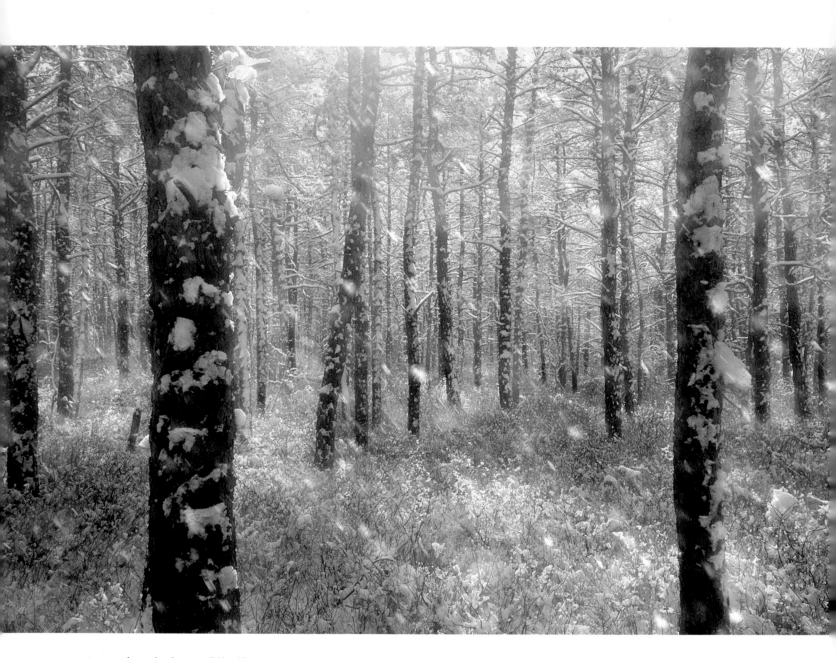

A sun-drenched snowfall offers a rare weather phenomenon and transforms Wharton State Forest into an enchanted land.

At Strawbridge Lake, a crisp, light frost on autumn maple leaves hints at the coming season.

The 1879 Emlen Physick Estate in Cape May is a fine example of Victorian Stick-style architecture. Physick's grandfather, Dr. Philip Syng Physick, was known as the father of American surgery. While Emlen Physick followed family tradition by completing medical training, he never practiced. Fully restored by the Mid-Atlantic Center for the Arts, the eighteen-room mansion now operates as a museum.

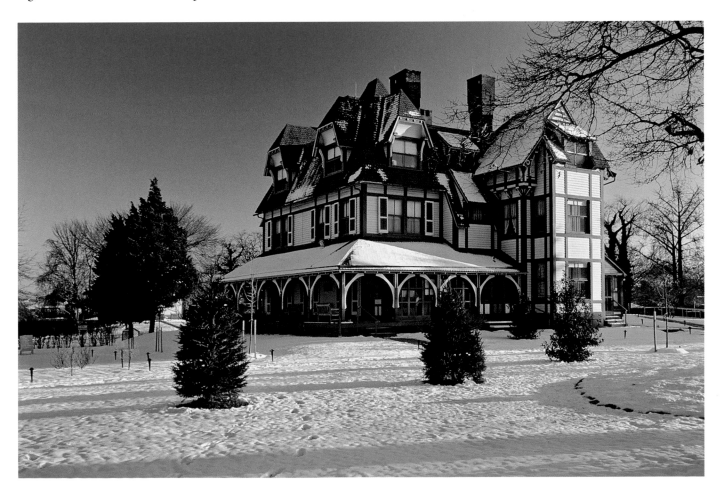

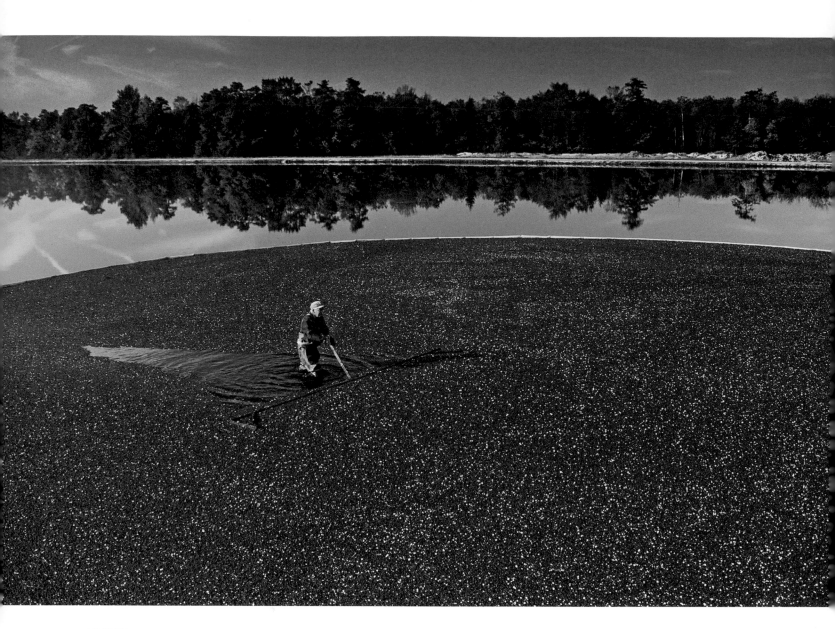

Cranberries are a major commercial crop in New Jersey; the state is the third-largest cranberry producer in the United States. To harvest the ripe berries, the low-lying shrubs are flooded in the fall and a water-reel-type thrasher shakes the berries off the vines. The floating yield is then corralled and pumped into waiting trucks.

OPPOSITE

Cranberries were first named by early European settlers in America who felt the closed flower and stem resembled the neck, head, and bill of a crane.

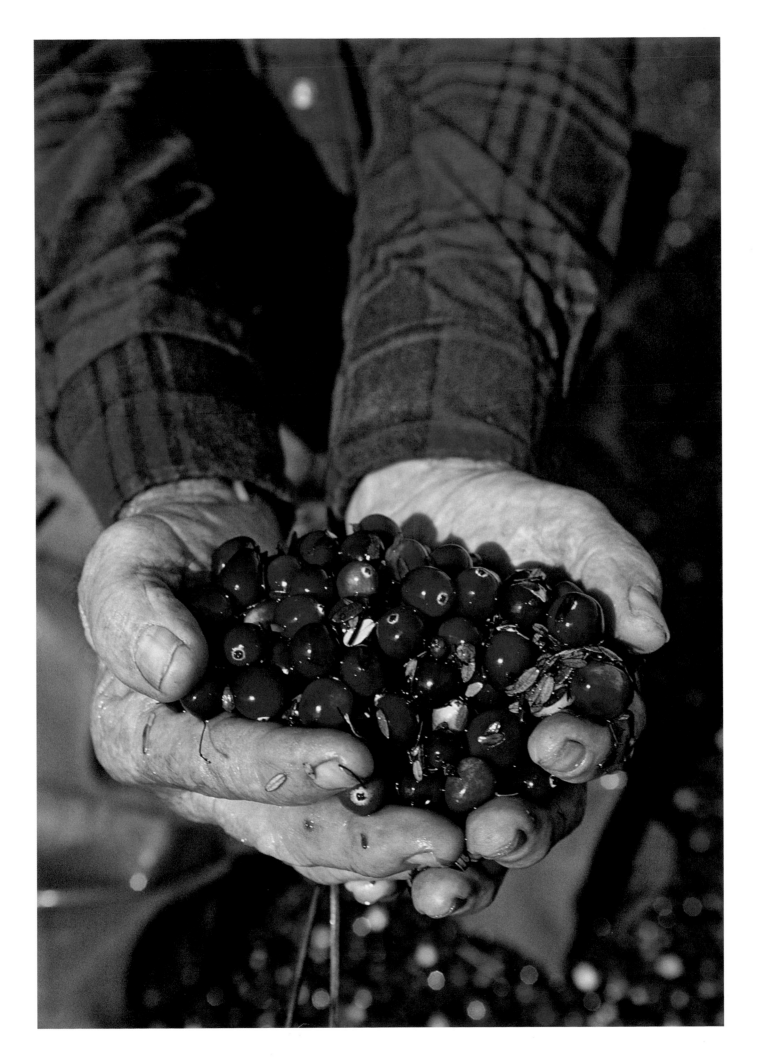

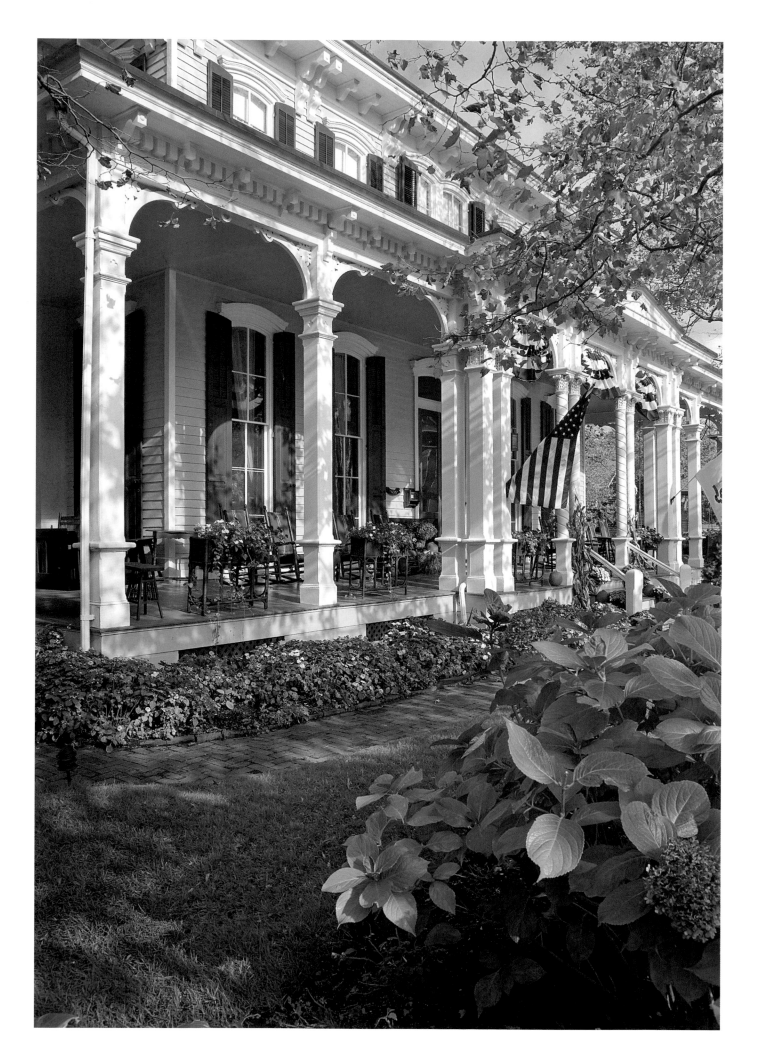

OPPOSITE
The Mainstay Inn in Cape May is a prime model of the
Victorian Queen Anne style. In 1972, when the entire city
of Cape May was placed on the National Register of
Historic Places, the Mainstay was recorded by the Historic
American Buildings Survey, and the architectural drawings
are now stored in the Library of Congress.

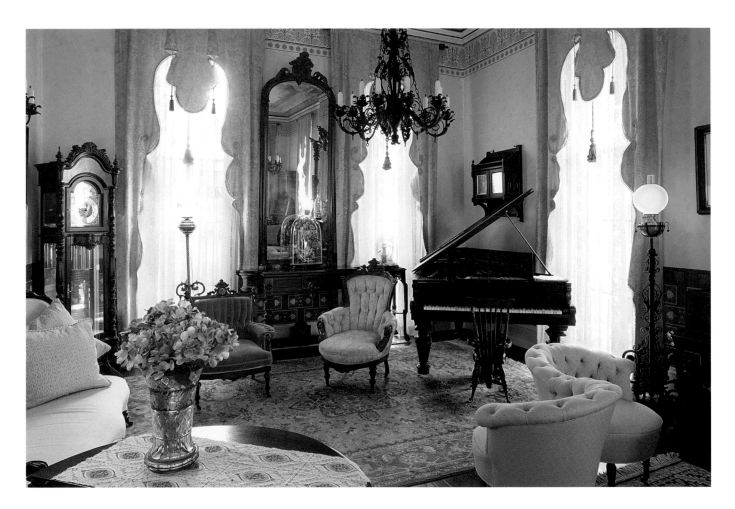

ABOVE
A classic example of a lavish, Victorian-style parlor can be found at the Mainstay Inn. Built in 1872 by famous
Philadelphia architect Stephen Decatur Button, the house was originally a private gambling club.

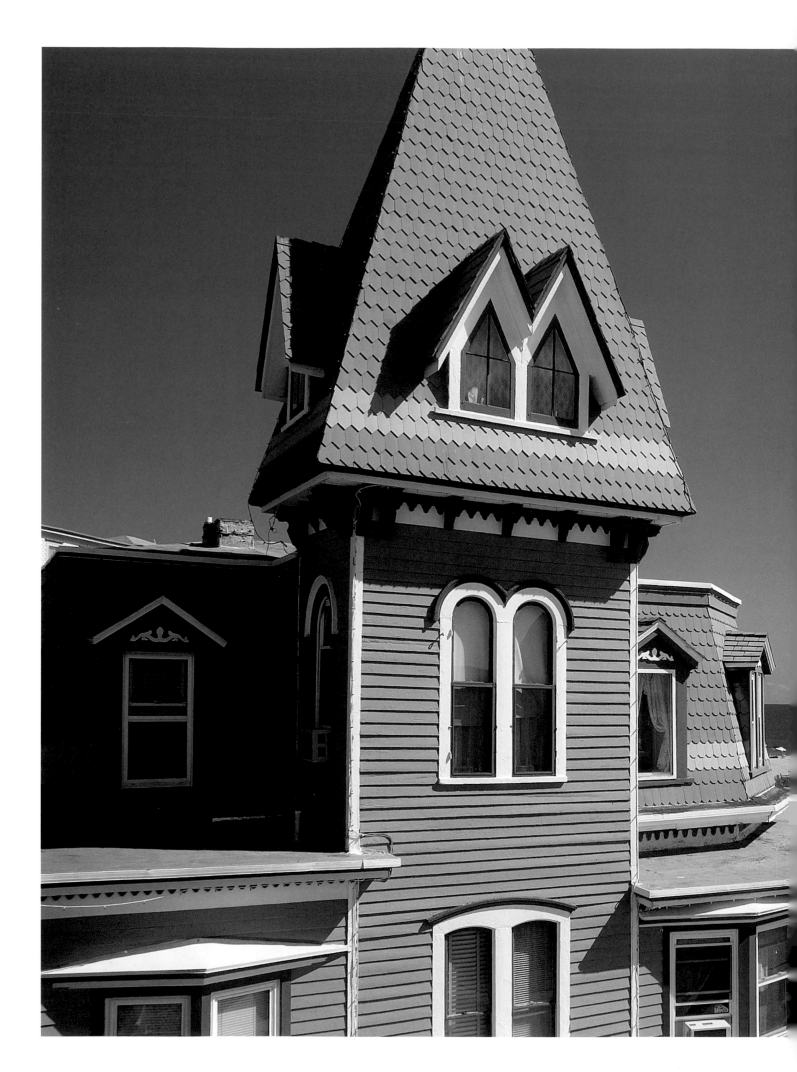

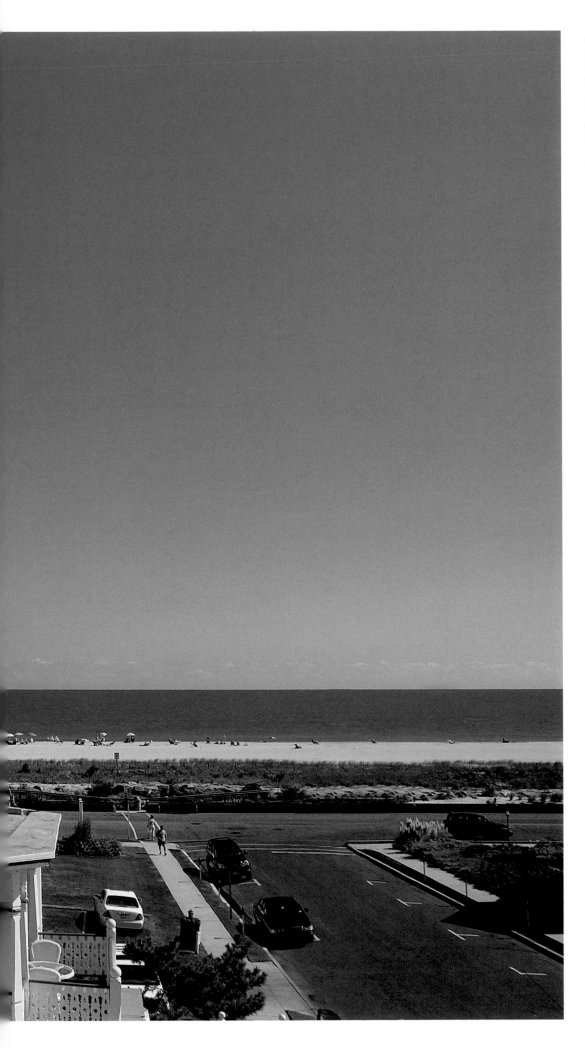

A classic Victorian seaside
resort overlooks the Atlantic
Ocean. Picturesque Cape May
is home to the largest
collection of authentic
Victorian structures in the
United States.

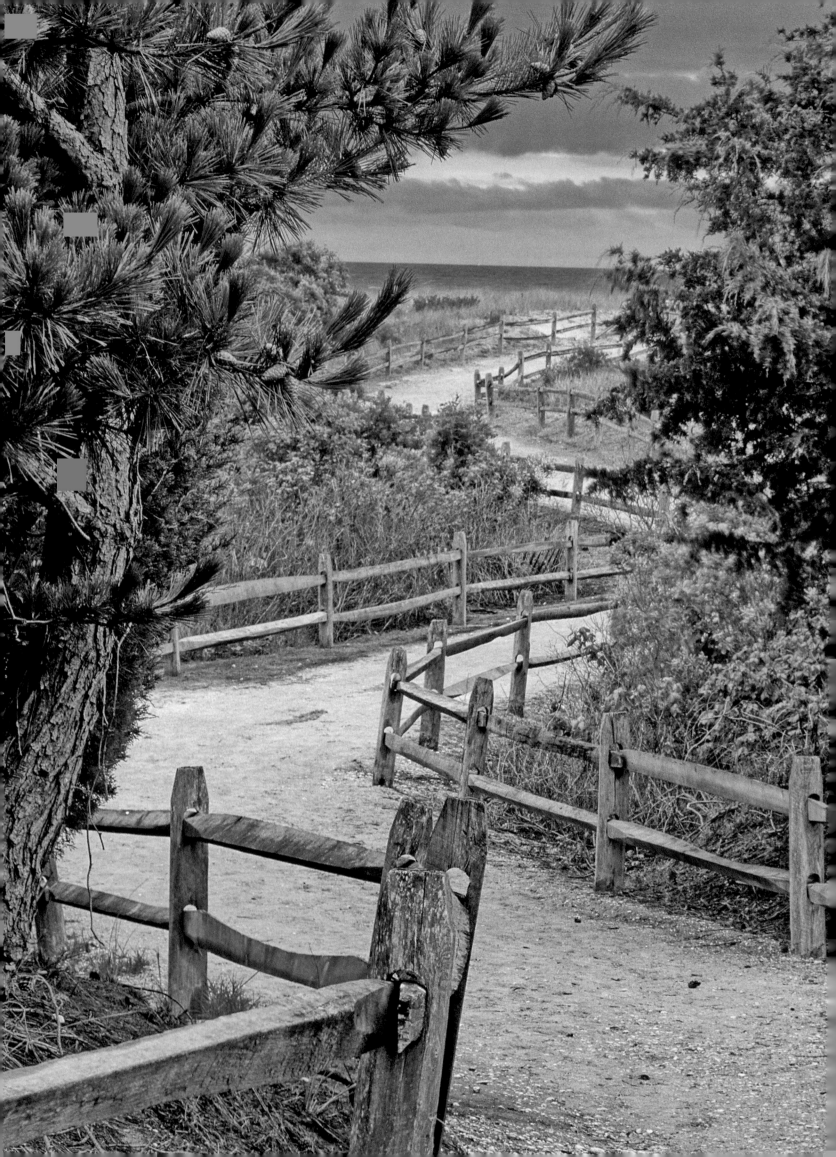

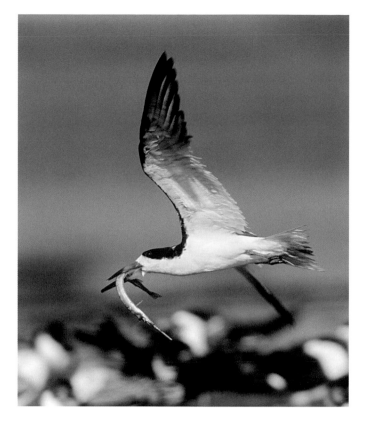

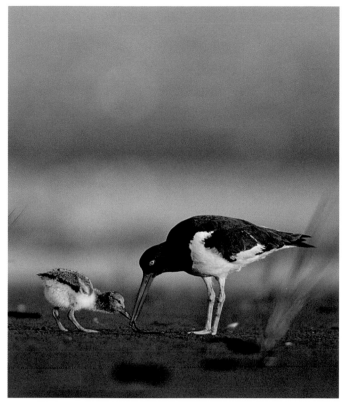

ABOVE

New Jersey is a birdwatching Mecca. Each spring and fall, droves of people from around the world visit the state to witness the mass migration of more than three million birds. This black skimmer pauses on its journey to catch an eel fish.

ABOVE

On the coastal mudflats at low tide, an American oystercatcher teaches its young chick how to find a marine worm. The young bird will not develop its own long red bill for months and relies solely on the parents to dig in the sand for invertebrates.

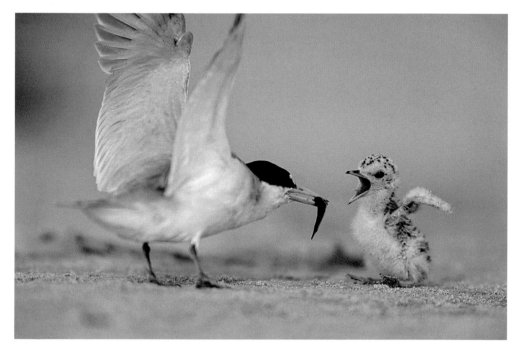

LEFT

An adult least tern feeds a fish to an ever-hungry chick along the Stone Harbor beach. The chick will be able to fly within three weeks of hatching, but both parents will be kept busy feeding the youngster until eight weeks later.

OPPOSITE

A winding path through coastal sand dunes in Avalon lures visitors to where the ocean kisses the white sandy beaches.

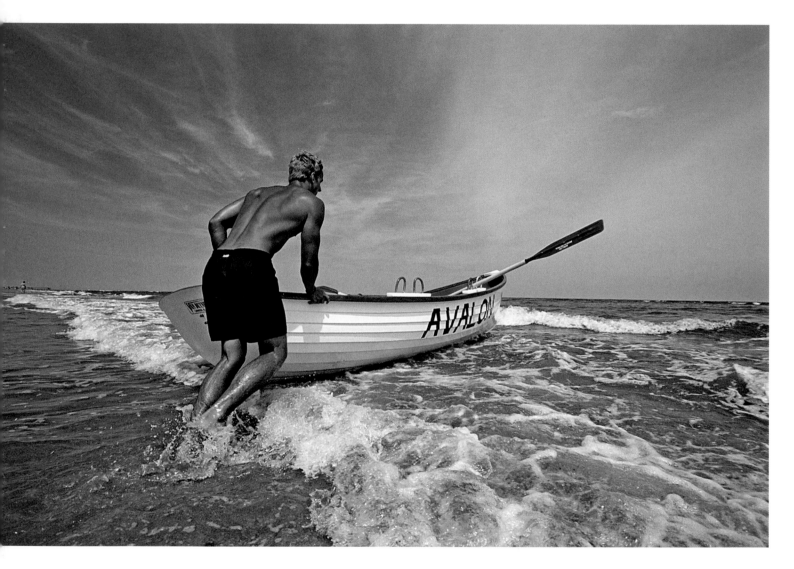

Protecting summer beachgoers from the undertow and currents of the Atlantic Ocean is an important job. Lifeguards constantly train to strengthen their skills and response time.

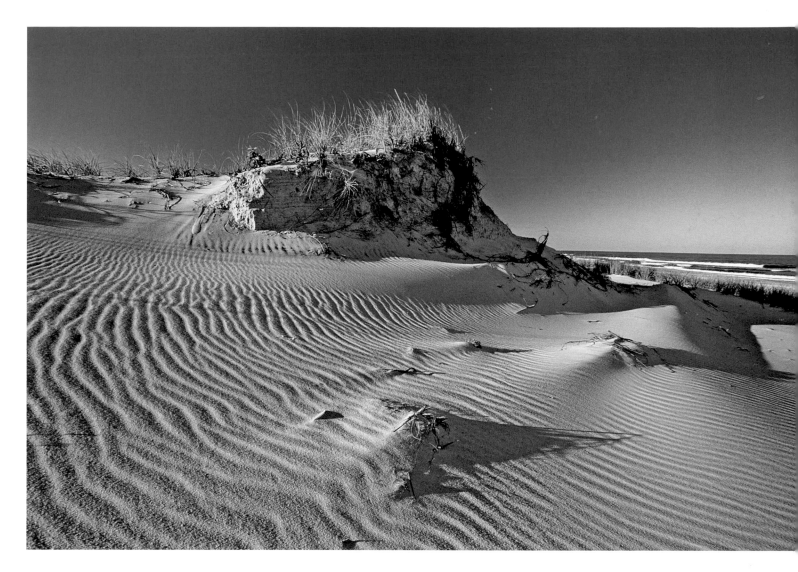

At Island Beach State Park, the effects of fierce winter storms can be seen in a "blowout," or depression, in the primary sand dunes. Just as the summer tides and winds create the dunes, winter storms from the northeast, called nor'easters, can ravage and destroy them, leaving barrier islands exposed to destruction.

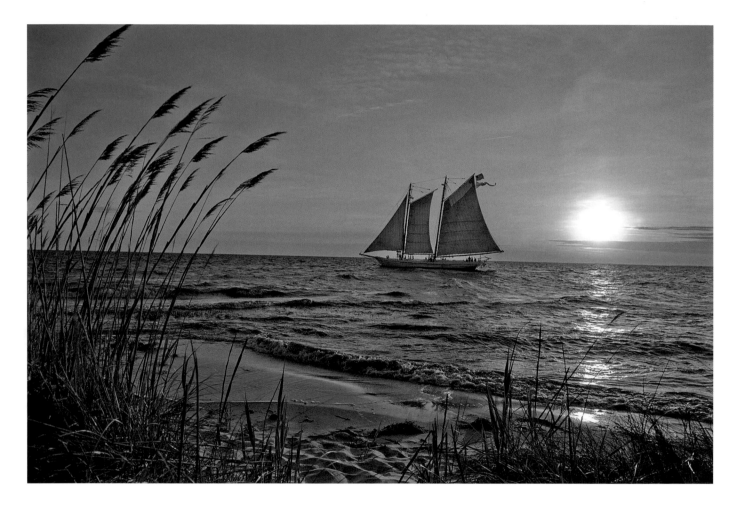

With the power of the wind filling her sails, the historic tall ship *A. J. Meerwald* navigates the currents in the Delaware Bay. Even if you don't know the difference between a spanker and a jib boom, landlubbers of all ages are always invited to join the crew aboard the ship as it rides over ocean waves.